CW01475530

WEIRD
IRELAND

Brinsley McNamara is a writer, video maker and adventurer. He is the protagonist of the Weird Ireland social media channel, where he wanders around the Emerald Isle looking for weird and fascinating stuff to document and quests to complete. He plans on clearing Ireland before moving on to elsewhere.

Brinsley hails from County Westmeath, a place immortalised in the book *The Valley of the Squinting Windows* by Brinsley MacNamara, who also hailed from the same spot.

This is his first book.

@weird.ireland
@weirdlyireland
@weirdireland

WEIRD IRELAND

An Unofficial Guide to the Island

BRINSLEY MCNAMARA

HACHETTE
BOOKS
IRELAND

First published in Ireland in 2024 by
HACHETTE BOOKS IRELAND

1

A CIP catalogue record for this title is available from the British Library.

ISBN 9781399741002

Typeset in Adobe Garamond Pro and TF-Gaelic by Palimpsest Book Production Ltd,
Falkirk, Stirlingshire

Printed and bound in Great Britain by Clays Ltd, Elcograf S.p.A.

Hachette Books Ireland policy is to use papers that are natural, renewable
and recyclable products and made from wood grown in sustainable forests.
The logging and manufacturing processes are expected to conform to the
environmental regulations of the country of origin.

Hachette Books Ireland
8 Castlecourt Centre
Castleknock
Dublin 15, Ireland

A division of Hachette UK Ltd
Carmelite House, 50 Victoria Embankment, London EC4Y 0DZ

www.hachettebooksireland.ie

CONTENTS

CULTURAL EPHEMERA

ODD ARTEFACTS

WEIRD LISTS

welcome to weird Ireland

Well, my name is Brinsley McNamara and welcome to Weird Ireland. If you've heard this introduction before, it means you've come across one of my videos on Instagram or TikTok, where I show you around the weird and interesting places, events and traditions of this wonderful Emerald Isle. If not, thanks for taking a chance on a book by a new author!

Weird Ireland came out of my obsession with novelties and oddities. I love anything that has a unique angle to it. Ireland has no shortage of quirky places, artefacts, traditions and lore: you just need to look around.

I started Weird Ireland in January 2024 because I wanted to share the everyday, extraordinary aspects of Ireland with the world. I had notions of becoming the Irish Louis Theroux by 2025, and while I don't like to toot my own horn, Weird Ireland hasn't done too badly. In my posts showcasing the oddities of Ireland, we've explored the length and breadth of the island.

In my Weird Ireland videos, you'll find scoops not only about history or folklore, but anything that seems normal to some, weird to others. A 30-second Instagram Reel

gives you a snippet of a peculiar topic, but this book enables you to explore those weird places and phenomena in greater detail.

Thanks for reading and seeya somewhere else in Weird Ireland.

STORIED PLACES

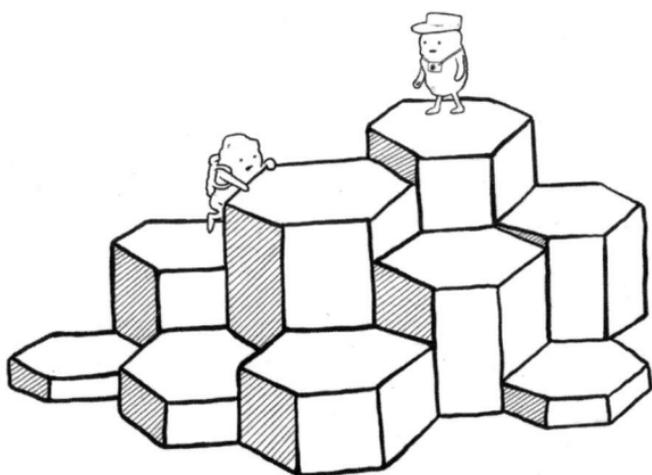

IRELAND'S MYTHICAL LANDSCAPE

Giant's Causeway, Bushmills, County Antrim

The Giant's Causeway is an otherworldly landscape of such proportions that it must count as one of Ireland's weirdest places. Over 40,000 basalt columns stretch along the north Antrim coastline in a mesmerising hexagonal formation.

For me, it's the most *iconic* weird place in Ireland. It's a stretch of about 70 hectares of coastline covered with flat, mainly six-sided stones that resemble a satisfyingly put-together jigsaw. And not only does it look weird, but the mythological origin story that gives the Causeway its name is truly spectacular. Legend has it that two giants – Fionn Mac Cumhaill in Ireland, and Benandonner in Scotland – had a falling out and decided to have a straightener by (depending on the version of the tale you prefer) either flinging rocks at each other across the sea or building a land bridge to close the gap so they could fight it out. Either way, the result was the Giant's Causeway, an uncanny landscape that looks both ethereal and manufactured at the same time.

The official story is that the Giant's Causeway was created 60 million years ago by lava flows cooling and making cracks that took the shape of what we see today. Picture mud drying on a hot day, shrinking and cracking. The cooling lava formed into mostly six-sided columns with four-, five-, seven- and eight-sided exceptions. It also forced the cooling rock upwards into vertical pillars. The lava cracks turned into the iconic shapes we see today because of a process called 'columnar joining'. In a nutshell, hexagons, or polygons are an efficient and strong shape for matter to take, and so, in nature, molten rock could take this shape when under tremendous stress. It's not dissimilar to the reason why bees make hexagon-shaped honeycombs. But 'The Columnar Joining Causeway' doesn't quite have the same impact, does it?

Back in the days when myths and legends gave theories to mysterious occurrences, it's not hard to see how tens of thousands of regular shaped rocks could be claimed to have been created by supernatural beings. Even today, the official explanation for why the rock columns are shaped into near-perfect polygon shapes is kind of complicated, to the extent where it's easier for people to enjoy the giant story.

Giant's Causeway is the most famous instance of what I like to call 'Irish landscapes made of myths'. Across the island, there are places that have a big story behind them – about how this god or that hero made things so. It was a way for folk back yonder to explain strange places to each other and amuse themselves at the same time. Mythical accounts are more enjoyable than any rational scientific explanation.

About Visiting

The Giant's Causeway is located three kilometres from Bushmills in County Antrim. It's accessible between dawn and dusk, and the visitor centre is open from 9am to 6pm every day of the week. Visiting the Causeway is free, but a trip to the visitor centre (or use of the main car park) will cost you!

IRELAND'S GATEWAY TO THE UNDERWORLD
Oweynagat, Rathcroghan, County Roscommon

In a backfield, off a backroad, in the back of County Roscommon, not far from Tulsk Town, there's a hole in the ground that is said to lead to the gate of Hell. It's definitely not the entrance to Purgatory – that's St Patrick's Purgatory in County Donegal. This hellhole is more commonly known as Oweynagat.

There are ancient associations between Oweynagat and the otherworld. One of these is from the *Adventures of Nera*. Nera, a warrior from Connacht, sees a vision of Queen Medb's fort at Rathcroghan razed by an otherworldly force that come from a nearby cave. Nera himself ventures down this cave and into the underworld. This story is set at Halloween, or Samhain in Irish, which may be why Rathcroghan became known as the home of Halloween. And the cave that Nera ventures down? That's called 'Oweynagat' or 'Cave of the Cats'. The name is said to come from the myth of *Bricriu's Feast*, where ferocious wildcats emerge from Oweynagat and attack three warriors.

From the mythologies written down in medieval manuscripts to local folktales from the vicinity, Oweynagat is loaded with extensive lore, which tends to paint the place in a nightmarish way. In other tales, the cave spirits and monsters that dwell in Oweynagat include the Morrigan (a shapeshifting battle goddess in Irish mythology), pigs that destroy the landscape and stop things from growing, deadly saffron-coloured birds and a three-headed monster. One folktale even claims that if you go down Oweynagat far enough you can end up in the Kesh Caves in County Sligo – however, this claim is unconfirmed.

Oweynagat is situated within the bigger historic complex of Rathcroghan, which in Irish mythology is a royal site – the seat of Queen Medb of Connacht. Archaeologically speaking, there are burial mounds there dating back as far as the Stone Age, with other historic sites from the Bronze Age, Iron Age and into the Middle Ages. It's a natural limestone cavern in a karst (limestone) landscape. The cave is about 37 metres long and in its lower chamber the ceiling is substantially higher than the height of an adult. The only graffiti in Oweynagat is a tag halfway down the passageway reading 'D. Hyde', which is said to have been carved there by Ireland's first president, Douglas Hyde. There used to be an earthen mound on top of the entranceway, so at one time it was grander looking than a big rabbit burrow, but that got knocked down sometime in the 20th century.

We may not have evidence of the appearance of otherworldly spirits from a hole in the ground in County Roscommon

around Halloween, but that's the thing with Oweynagat and Rathcroghan in general: myth and history live side by side there. There are even ogham inscriptions in Oweynagat bearing the name of Medb. Many of the aspects of the myths contradict greatly the archaeological evidence, but it's likely that Rathcroghan was a place for meetings, ceremonial assemblies and ancient festivals, especially at times of the year when one season moves to another, such as Halloween.

About Visiting

While Oweynagat is part of the Rathcroghan complex, it is on private land. To access it you should first head to the Rathcroghan Interpretative Centre in Tulsk, County Roscommon, which is open 9am to 5pm, Monday to Saturday.

FOUR KNOCKS
Stamullen, County Meath

In Ireland, Newgrange gets all the clout when it comes to neolithic passage tombs. And not without good reason. All the way from the Boyne River Valley in County Meath, measuring in at a whopping 85 metres in width and 12 metres in height, Newgrange is not only Ireland's largest Stone Age tomb, but one of the biggest in the world.

Built in around 3200 BC, its flex is that it's a tomb older than the pyramids of Giza, despite not making it into the Seven Wonders of the Ancient World. No one's quite sure when Newgrange was forgotten, but in 1699 AD it was 'discovered' by farm workers digging into what at the time looked like a broad little hill. Inside, they found an inner chamber built out of stone slabs with megalithic art carvings, as well as Stone Age jewellery, tools and human remains.

A gift left by the prehistoric architects of Newgrange is the roofbox above the entrance, which wasn't noticed until 1967. The roofbox is a thin gap that opens to the outside, but doesn't let in much light. However, every winter solstice

around 21 December, the angle Newgrange is positioned directs the sunlight to illuminate the whole inner chamber through the roofbox. How did prehistoric builders – whose names, languages, beliefs, lifestyles, fears, hopes and dreams we cannot imagine beyond what can be excavated – manage to calculate the only possible angle to project the sun's glow on the darkest day of the year into this chamber? One thing's for sure, they were certainly no eejits if they could construct a mausoleum that's still standing 5,000 years later.

Viewing the winter solstice from inside Newgrange is near impossible as tickets for the annual event are like gold dust. Only about sixty people can enter and ticket allocation is decided by a lottery. The good thing is, sunrise on a winter-solstice morning isn't until nearly 9am, so you won't have to go especially early. The bad thing is, if it's a cloudy and dark morning, then tough – the sunlight won't reach the inner chamber.

By the way, the signature white outer walls of Newgrange aren't original, they were added in the 1960s, which may displease historians and archaeologists, but they sure do pop in photos.

See how easy it is to focus on Newgrange? Now, what if I told you that there's another smaller passage tomb nearby and all you have to do is drive down the road and borrow the key from a neighbour to get inside?

Four Knocks is far smaller than Newgrange, less old and does not align with the sunrise on a winter solstice morning

like Newgrange. However, it is still an impressive relic of Neolithic architecture.

The innards of Four Knocks were gutted in the 1950s and brought to the National Museum in Dublin. The artefacts within included dozens of human remains, and unique specimens of pottery fragments and beads. The current roof isn't original either, unless the prehistoric Irish invented concrete. However, many of the incredible megalithic wall carvings are still visible, including one of the first-known depictions of a human face.

Newgrange and Four Knocks have dramatically transformed in form and function over thousands of years, from immense Stone Age construction sites to revered monuments of prehistoric culture to entering eras where they were forgotten and later rediscovered. They are now important centres for tourism, study and veneration of the ancients.

About visiting

Four Knocks is located four kilometres northwest of Naul, County Dublin, and is free to visit. To obtain the key you must give a €5 deposit to a local resident, which will be refunded on return of the key. The resident's phone number and address are available online.

THE ÉIRE SIGNS

On 3 September 1939, the United Kingdom and France declared war on Germany. Two days earlier, Nazi Germany, under the dictatorship of Adolf Hitler, had invaded neighbouring Poland, sparking what would soon become World War Two. Ireland immediately enacted the Emergency Powers Act, which sought to protect Irish neutrality at all costs.

In subsequent years, more than thirty countries joined the war either on the side of Germany, Japan and Italy as the Axis Powers, or the UK, USA, France, the Soviet Union and China as the Allied Powers, or through invasion and occupation by an aggressor.

In the midst of the deadliest war in human history, a few countries managed to sit it out. Amongst them were the neutral countries of Switzerland, Sweden and Ireland. Ireland, officially called Éire at the time, remained neutral for the whole six years of the war.

However, due to the proximity of Ireland to Great Britain and Northern Ireland, danger of accidental bombing by either Allied or Axis pilots was always present. There were a number

of incidents involving German bombers mistaking parts of Éire for the UK and dropping their murderous load. A creamery in Campile, County Wexford was bombed in August 1940, killing three women. Most infamously, in January 1941, German bombs killed 28 people in Dublin.

As a way of mitigating the danger of rogue bombings, the government used whitewashed stones in concrete to write 'Éire', along with a number, on the coastline of Ireland. These signs were clear signals to pilots that they were flying over a neutral country. The number on the sign corresponded to a location to aid Allied pilots in their navigation if they got lost. At least 83 of these signs were erected and possibly more that are now forgotten.

There has been no government effort to preserve the signs since the end of the war, although local community efforts aim to protect and maintain them. One of the best kept signs is Éire 80 at Malin Head, County Donegal. However, many of the signs are in a state of great disrepair, and others are completely covered and forgotten.

Éire 6 on Howth Head, County Dublin was revealed after a gorse fire in 1982. In the summer of 2018, a drought in parts of Ireland caused by prolonged heat and low rainfall revealed archaeological markers which lead to new discoveries. These included a previously unknown ancient monument near Newgrange, and the rediscovery of an Éire sign on Bray Head, County Wicklow, after another gorse fire burned out the vegetation that had been covering it.

These iconic signs remind us of a time in Ireland before

GPS where bad flying conditions could cause a bomb to land on your bedroom. As good a reason to preserve them as any, I think.

About Visiting

The Éire signs are located around the Irish coastline. More information on their locations can be found online. Many of the Éire signs are located on private land, in which case permission should be sought from the landowner before approaching.

THE BLACK PIG'S DYKE
Southwest Ulster
and Northeast Connacht

The old story goes that there was once a wicked schoolmaster who would turn his pupils into hares during class, then transform them back into humans before they went home. The parents, noticing their children were exhausted after school, started asking questions. When the kids explained what their teacher was doing to them, the parents confronted him. They asked him to demonstrate his magic, and so he turned himself into a pig. The parents quickly destroyed his book of magic leaving him stuck that way. Incandescent with rage, he tore up and down the country boring a trench with his snout, leaving deep ditches and raised banks, which are now commonly known as the Black Pig's Dyke.

These discontinuous linear earthworks run across nine counties and have several different names, depending on which county you are in. They are also known as the Worm Ditch, the Worm Dyke, the Black Pig's Race, the Black Pig's Valley and the Black Pig's Rut. The worm version comes

from a story where the dyke was made by a giant worm or snake (or *ollphéist* in Irish) slithering and drilling across the country.

The origin of the Black Pig's Dyke is a contested thing. And, unlike another mythological marvel of Ireland, the Giant's Causeway, there is no one agreed explanation for how it came into being.

When it was first studied in the 20th century, the ideas that floated around were that it was a defensive boundary between Ulster and the rest of Ireland, or it was a facsimile of Roman walls in Britain (like Hadrian's Wall). However, these theories have since been disproved with archaeological evidence pointing to sections of the Black Pig's Dyke as dating from the Bronze and Iron Ages.

Back in its heyday, stretches of the Black Pig's Dyke would have been monumental. Part of the dyke was excavated at Scotshouse, County Monaghan in the 1980s, and it was revealed that the dyke there would have measured over 20 metres in width, with a wooden palisade on one side that was around three metres in height.

The origin of the Black Pig's Dyke is probably not fully understood yet. Hopefully its memorable name and compelling mythological roots will capture public awareness and lead to further archaeological study to give us a greater understanding of the people and the reasoning behind its construction.

About visiting

The Black Pig's Dyke is located across stretches of the northern counties of Ireland. One of the most notable sections is located at Aghareagh West, 2.5 kilometres south-east of Scotshouse, County Monaghan. However, most of the Black Pig's Dyke is located on private farmland and, as such, permission of the landowner must be sought before attempting to visit.

THE GERMAN MILITARY CEMETERY
Glencree, County Wicklow

Picture this: it's World War Two and you're a bomber pilot who has survived a crash landing in neutral Éire.

The bad news is that you're interred in a prisoner of war camp for the duration of the conflict. The good news, if you're an Allied pilot, is that you'll get leave time from the camp to visit the surrounding villages. Chances are, you'll make your way to Northern Ireland to rejoin the services. However, if you're a German pilot you won't get the same freedoms and so you'll likely sit out the rest of the war in an Irish internment camp.

Any German military personnel who died whilst interned, or died upon crashing in Irish territory, were buried in the German War Cemetery in Glencree, County Wicklow, otherwise known as Deutscher Soldatenfriedhof Glencree. The graveyard houses 134 graves, six including World War One internees, 46 German civilians whose ship was torpedoed

off the coast of Donegal and a German spy sent to make contact with the IRA in 1940.

The cemetery is managed by the German War Graves Commission and provides the rural area with a peaceful if anomalous aura, which one could only expect from a German wartime graveyard nestled in the uplands of County Wicklow.

About Visiting

The German Military Cemetery is located in Glencree, County Wicklow. It is free to visit and is open every day of the year.

THE MAN IN WILLIAM BUTLER YEATS' GRAVE
DRUMCLIFFE, COUNTY SLIGO

William Butler Yeats is dead. That's a pretty uncontroversial fact. What is in doubt, however, is exactly who is buried in the grave marked 'William Butler Yeats'.

We all know W.B. Yeats to be one of Ireland's most famous and revered poets. Many of us studied his poetry for the Leaving Certificate and can recite his most famous lines. As well as a poet, he was a playwright, politician, Nobel Prize literature recipient and ardent nationalist.

Yeats was born in 1865 in Sandymount, Dublin, and lived most of his life between Dublin, Sligo and London. However, it was the sights and landscapes of Sligo that influenced some of his most important works, including his much-recited poem, 'The Lake Isle of Innisfree', a stanza of which is featured on the inside of Irish passports.

To this day, Yeats is a big deal in Sligo. There's a statue of himself in Sligo Town that was unveiled in 1989 on the 50th anniversary of his death. There's even a dedicated

W.B. Yeats app that points out sights relevant to him around the county.

Yeats died of heart complications in January 1939 in a hotel on the French Riviera at the age of 73. He was buried in Roquebrune-Cap-Martin in France, but one of his last wishes before his death was to be buried in Sligo. Because of World War Two, his remains were not brought back to be reinterred until 1948.

In Drumcliffe Parish Church, a simple headstone engraved with lines from his own poem 'Under Ben Bulben' marks the final resting place of one of Ireland's most significant modern poets. However, in a weird twist of events, this may not actually be the case.

As far back as the reburial in the late 1940s, there were rumours that the repatriation had not entirely gone according to plan. In the few years between Yeats' original burial and the move back home to Sligo, his remains had been dis-interred into an ossuary containing any number of other human remains. It's not known how much of Yeats' remains, if any, made it back to Ireland.

His children were sure that it *is* his remains that rest in the grave in Drumcliffe. However, papers of the French foreign ministry discovered in 2015 shed a more sceptical light on the issue, suggesting that Yeats' remains were mixed with the remains of others. Short of exhuming him from his grave for a third time to perform a DNA test, there's no way to know for sure.

About Visiting

William Butler Yeats' grave is located in Drumcliffe Cemetery, 7.5 kilometres north of Sligo Town. It is free to visit and open every day of the year.

THE MYSTERY OF THE LONG WOMAN'S GRAVE
CORRAKIT, COUNTY LOUTH

We now move on to a more romantic yarn. It was said that, on his deathbed, the Chieftain of Omeath requested that his land be split between his two sons, Conn and Lorcan, when he died. When the chieftain's last day came and went, Conn brought Lorcan up to the mountains and made an eejit of him by telling Lorcan that he could have as much land as he could see. However, this was very little, because he brought him into a foggy part of the mountain. Lorcan's legacy was the side of a few rocky hills.

But Lorcan owned a ship and began trading overseas, becoming quite prosperous. He sailed to Spain where he met Cauthleen, a Spanish noblewoman reputed to be seven foot tall, whom he married, with promises of land and wealth in Omeath. When the couple arrived back in Louth, Lorcan brought his new bride to his rocky patch of land in the mountains. The sight of the tiny parcel of hilly land put the wind up Cauthleen so much so that she dropped dead on

the spot. Lorcan was so affected that he flung himself into a bog and was never seen again. Locals found Cauthleen's body and buried her in the hollow where she lay, depositing stones and creating her burial cairn. This became known as the Long Woman's Grave.

These days, the mythologised spot is a six-metre-long outline made of stones with a headstone plaque on a barren roadside near Omeath Town. The plaque tells the above story. But is there anything to this ancient myth? Short of excavating the stony strip of land that was Lorcan's only inheritance to see if there's the skeleton of a seven-foot-tall woman buried beneath, we can't know for sure.

But is there any harm in a popular story with no truth in it bringing appreciation to an otherwise unremarkable stretch of road?

Well, it sure can have real-world implications. The spot has a car park that caters for busloads of tourists who visit each day to listen to the ill-fated myth and visit Cauthleen's alleged resting place.

In 2016, the story of the Long Woman's Grave almost sparked an international crisis when there was talk in the locality about exhuming Cauthleen to reinter her in a grave overlooking Carlingford Lough. Locals from Omeath protested at the Long Woman's Grave to protect her burial in their neighbourhood, and this is where Cauthleen remains today. So, even if there's no certainty about who is in the Long Woman's Grave, we can at least say that belief in the legend certainly leads to stories that are just as interesting.

About Visiting

The Long Woman's Grave is free to visit. It's located in the Windy Gap on the Cooley Peninsula in County Louth. There is ample parking.

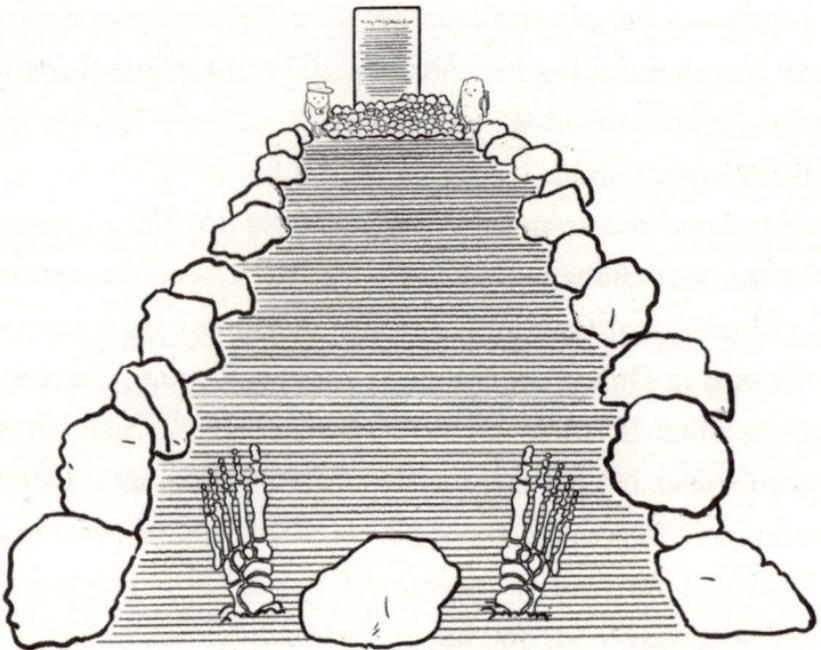

DAN DONNELLY'S FOOTPRINTS
Blackrath and Athgarvan, County Kildare

The Curragh in County Kildare was once a large, unfenced grassland where sheep were allowed unimpeded freedom to roam into towns and onto roads as they pleased. This ovine paradise is full of vivid folklore, most famously the story of St Brigid spreading her cloak to cover the entire Curragh and claim the land for a monastery.

It is also home to the natural sticky hollow where a legendary boxer claimed victory over his English opponent in front of thousands of spectators in a fight that was so celebrated that they built a monument in his honour.

Born in Dublin around 1788 to a large and poor family, Dan Donnelly took up boxing because of his pugnacious nature and his big stature – he was six feet tall and had unusually long arms. Boxing in the 19th century was bare-knuckled and had considerably fewer rules than the sport today. It was bloody and brutal, and boxers could get horribly

injured, or killed. In 1815, at the age of 28, Dan fought an English boxer called George Cooper in Belcher's Hollow, a natural amphitheatre in the Curragh. Both pugilists were champions by the time of the fight, and the outdoor arena was filled with a huge crowd in anticipation of some heroic bouts. The hollow was a popular spot for big boxing matches, and up to 20,000 punters came to see this clash of the titans.

The fight between Donnelly and Cooper was seen as more than just two big lads throwing hands. It came to symbolise the Irish struggle, coming only 17 years after the failed United Irishman's Rebellion and 12 years after Robert Emmett's defeated uprising. Wellington had just defeated Napoleon at Waterloo and Britain had never been stronger. The Irish fans needed a win, and Dan Donnelly delivered. After 11 savage rounds, Dan came out on top and George Cooper was left brutally defeated and with a broken jaw.

The legend goes that when Big Dan triumphantly marched out of the boxing arena on that day in 1815, his heavy tread left huge imprints in the boggy soil. They were still there when a stone monument was erected in 1888, and they remain there to this day.

Legends aside, if one thing is for sure, it's that Dan Donnelly's legacy won't be forgotten by the people of the Curragh, Kildare anytime soon.

In 2008, Donnelly was inducted into the International Boxing Hall of Fame, and because of his timeless victory at Belcher's Hollow, it was renamed Donnelly's Hollow.

Dan's story doesn't end there. Not by a few more rounds yet.

His legacy goes beyond his deeds to focus on the physical attribute that brought him fame – his right arm (more on this later).

About Visiting

Dan Donnelly's footsteps are located in Donnelly's Hollow, 3.5 kilometres south of Newbridge, County Kildare. It is free to visit and open every day of the year.

THE MAGIC HILLS OF IRELAND

If you've ever taken the handbrake off your car while parked on the bottom of a hill and had it mysteriously roll upwards instead of down, you were, in fact, not parked on a normal hill, you were parked on a magic hill. Also, you are not going mad. It did really just happen.

Magic hills are found all over the world. They also get called gravity hills, magnetic hills or mystery hills. What's really happening is a trick of the eye. The countryside surrounding the road on the hill gives the impression that it's on an incline when in fact it's a slight decline, so the car is always rolling downhill.

That doesn't mean it's not impressive to watch a car seemingly roll up a hill, or that it's easy to do. I've personally tried a few of the magic hills of Ireland and have only rolled up one of them so far. You need to be parked in a very specific place, and many of them are on busy roads, so the person in the car behind you might not give you the few minutes you need to get it right.

One of the best-known magic hills in Ireland is near the gates of Spelga Dam in the Mourne Mountains, County

Down. One local story placed car-pushing fairies at the heart of the hill magic.

Another magic hill can be found on the Cooley Peninsula, County Louth. It's on a quiet stretch of road just off the Jenkinstown Cross. This one is hard to get to but, by God, it does work when you do manage to find it.

Dartry Mountains, County Sligo, boast not one, but two magic hills. One is located behind Ben Bulben, and the other on the Gleniff Horseshoe.

A Munster magic hill is to be found in the Comeragh Mountains, County Waterford, situated on the road towards Mahon Falls coming from Mahon Bridge.

The eerily named Devil's Pull is located outside Ballymahon, County Longford.

I could go on all day listing these hills, and more are discovered all the time. My advice is to stay calm if you stop your car on a hill and it starts moving uphill, and please mark the location so everyone else can try it out too.

About Visiting

Magic hills are on public roads and, as such, are free to visit and open every day of the year. However, caution must be exercised when attempting to roll up a magic hill on a public road.

THE HELLFIRE CLUB
montpelier Hill, County Dublin

The Hellfire Club might be the most iconic haunted place in Ireland, and the satanic name probably has a lot to do with that. It is an imposing former hunting lodge situated at the very top of Montpelier Hill in the Dublin Mountains (or Wicklow Mountains depending on who you ask), about five kilometres from Tallaght. These days, the car park leading up to the club is packed every weekend with the cars of tourists and hikers keen to trek up the hill to visit this ominous place where infamous stories of devil worship, murder, debauchery, antiquity vandalism and hauntings allegedly unfolded. It's easy to see why. The two-storey stone building, which is completely accessible, resembles something from a horror movie.

So, what exactly are these stories?

First things first. The stone hunting lodge was built in 1725 by wealthy lawyer and landowner William Conolly. He used the stones of a nearby megalithic cairn to construct the lodge. People say that's where the badness begins because,

only four years after the lodge was built, Conolly was dead. He died of a stroke in his house on Capel Street in Dublin on 30 October 1729, the night before Halloween, which is known to some as Devil's Night.

The lodge was dubbed The Hellfire Club thanks to a clique of upper-class men in the 1730s and 1740s who were notorious in Dublin for their terrible conduct. Their group included the First Earl of Rosse, Richard Parsons, and the Fourth Baron of Santry, Henry Barry, and they were known to engage in heavy drinking, gambling, womanising and blasphemy.

This being the Age of Enlightenment, a period in the 18th century when rationalism and empiricism were in and conventional religion was out, Parsons and Co. engaged themselves with black masses and devil summoning. This wasn't because they were satanists but because they were trying to show disrespect towards conventional religion, as was the style at the time.

The Hellfire Club would meet at the Eagle Tavern on Cork Hill in Dublin, but it is said that they moved their activities to the abandoned hunting lodge.

One of the weirder stories that comes from their tenure on the hill was that a man came to the door one night while the Hellfire Club members were playing cards. He joined them for a game and, when a club member bent down to pick up a dropped card, he saw that the stranger had cloven hooves instead of feet, a sign of none other than the devil himself.

A stranger with cloven hooves is a surprisingly common archetype in Irish folklore, and the Schools Collection from the National Folklore Collection has a tranche of tales of goat-footed folk. This phenomenon reportedly happened as recently as the 1950s when a dancehall run by a Monsignor Horan in County Mayo was visited by a handsome stranger with hairy legs and cloven hooves.

Far more folktales abound about the men in the Hellfire Club, including that they had a black cat as a mascot, which was really the devil in furry britches. It is said that if you walk around the Hellfire Club 13 times, you'll meet the devil. If you do survive the hike up to the lodge, make sure to enjoy the view across Dublin, but keep one eye open for strangers sporting a hoof instead of a foot.

About visiting

The Hellfire Club is located seven kilometres southeast of Tallaght in the Dublin Mountains. It's free to visit and open every day of the year. It is accessed from the Hellfire Wood car park, which can get busy.

THE MEATH GAELTACHT
Ráth Chairn and Baile Ghib, County Meath

Irish (or Gaelic or Gaeilge) was at one time the majority-spoken language in Ireland. However, by the 21st century, everyday usage of Irish has become pretty much confined to Gaeltacht areas. Gaeltachts are regions where Irish is the first language, road signs and placenames appear only in Irish (except for Dingle, which goes by that name as well as Daingean Uí Chúis). They are popular places for students to go to learn and practise Irish.

Almost every Gaeltacht region is situated on the Atlantic coast of the island. Counties Donegal, Mayo, Galway, Kerry, Cork and Waterford have Gaeltachts with different dialects depending on whether they're in Ulster, Connacht or Munster. What a lot of people might not know is that Leinster has two Gaeltacht areas, both in County Meath (Contae na Mí). This is kind of weird, because Irish had been replaced by English in the region for a few hundred years.

The Meath Gaeltacht is the smallest of them all, comprising

the two villages of Ráth Chairn and Baile Ghib. It is also, in fact, the new kid on the block, having only been established in the 1930s, when families from the Connemara Gaeltacht moved there to farm land acquired by the Land Commission as part of a government effort to promote Irish speaking in the eastern regions.

And of all things, it started with a bicycle protest. On 29 March 1934, a convoy of Gaeltacht activists cycled from Connemara to Dublin to present a petition on issues important to Gaeltacht regions to politicians. This event was called *an turas aniar* – the journey east – and is believed to have led to the creation of the Meath Gaeltacht the following year.

This cunning plan of relocating families from Irish-speaking Connemara to English-speaking Meath was not without its problems though. For one thing, none of their new neighbours could understand the settlers, so, instead, the Connemara families had to learn to speak English, which kind of defeated the objective.

Despite only moving about 200 or so kilometres, the landscape, lifestyle and culture of Meath were different enough from Connemara to make many of the newcomers lonesome for the dramatic treeless hills of the West. So much so that some even returned home.

A few of the Meath locals took umbrage to land being given to folk from far away. There are accounts of Meath locals blaming the new families for getting the best of farmland for nothing, and still visiting the dole office each

week. One conspiracy theory from the time was that the establishment of the new Gaeltacht wasn't to promote the Irish language but to increase the number of Fianna Fáil voters in the constituency.

Sadly, there are reports of violence and intimidation from that time too. Land Commission officials were attacked by locals, Irish-speaking migrants were harassed by gangs and told to give up speaking in their native tongue, more gardaí had to be stationed in the area at times, and the Ráth Chairn Gaeltacht was frequently described as a 'colony' and 'plantation' in the newspapers and by the locals.

Despite the initial static between the migrants and locals, the animosity died down over the years, and the appreciation of the Irish language grew until it became widely used in the locality.

If you visit these days, the towns won't look terribly different to any other rural Irish village or town. That said, you'd want to know a *cúpla focal* of the Irish to help navigate your time there.

About Visiting

The Meath Gaeltacht is located at Ráth Chairn, County Meath, five kilometres east of Athboy, and at Baile Ghib, County Meath, 11 kilometres northwest of Navan.

SCOTIA'S GRAVE AND IRISH PSEUDO-HISTORY
Tralee, County Kerry

Is there anything weirder than discovering that an ancient Egyptian princess's final resting place is on the side of a boggy slope in County Kerry, rather than a pyramid in Giza?

Just a ten-minute drive from the bustling town of Tralee, home of the unique event that is the annual Rose of Tralee festival, lies Scotia's Grave. It is the supposed resting place of Scotia, a daughter of an Egyptian pharaoh who came to Ireland about 3,500 years ago to avenge the death of her husband who died in battle against a race of primordial Irish fairy folk.

If you don't remember being taught about the war between the Milesians (Scotia's husband's gang) and the Tuatha Dé Danann (the godlike, mythical gang) in your history lessons at school, that's because they are based firmly in mythology.

According to legend, Scotia made her way to Ireland to battle the Tuatha Dé Danann at Sliabh Mish and, though victorious, she was killed in the fray. Scotia's Grave is where

41

she fell, and she was buried in this glen, fittingly called Scotia's Glen in her honour. Her grave comprises a small circle of flat stones and, according to local tales, ancient Egyptian hieroglyphics were inscribed on them.

The myth of Scotia occupies an odd place in the folklore of Ireland because, rather than being called a myth or legend, it's sometimes called a pseudo-history. This is simply because, when the story was written, it was under the pretence that these fantastic events weren't simply mythical stories folk told each other for amusement, but were genuine historical events, regardless of a lack of evidence of said events. The first written mention of Scotia is from the medieval Leabhar Gabhála Éireann, also known as the *Book of Invasions*, which isn't actually a book as much as a collection of writings by different people amassed over hundreds of years.

These days, the story of Scotia is widely seen as having no basis in real events. However, to the people of Tralee, the folktale has a rich tradition going back centuries. Stories are gleefully recounted about how she landed her forces from Spain in Kenmare Bay, how her death was caused by a fatal fall from her horse and of the treasure trove of gold jewellery that remains buried with her in the glen.

Magical stories like these give meaning to a place that people appreciate, honour and pass on from one generation to the next, so much so that Scotia was crowned the first Rose of Tralee.

About visiting

Scotia's Grave is located six kilometres south of Tralee, County Kerry. It is a 15-minute walk to reach the glenside grave from the nearest entry point. Scotia's Grave is free to visit and open every day of the year. Parking at the entrance point is limited.

IRELAND'S OLDEST BAR(S)
Sean's Bar, Main Street, Athlone and The Brazen Head, Usher's Quay, Dublin 8

The town of Athlone in the far west of County Westmeath is commonly regarded as the centre of Ireland. It is situated right on the River Shannon and, historically speaking, it was an important crossing point. Given its strategic importance since the Bronze Age, it makes sense that Athlone is home to Sean's Bar, the oldest continuously run pub in Ireland.

While on first impression it looks like any town pub, Sean's Bar, located on Main Street in the shadow of Athlone Castle, has been in constant business since about 900 AD.

The current building dates from the 17th century. However, across from the pub's front bar is a decrepit section of wall that is at odds with its otherwise cosy, traditional aesthetic. This dates from the 10th century and is comprised of wattle, wicker, horsehair and clay. These remnants, along with old coins, were discovered in the 1970s and, as a result, Sean's Bar now holds the esteemed title of Ireland's Oldest Bar.

There's just one problem. A rival pub, The Brazen Head,

also proudly proclaims across its exterior to be Ireland's oldest bar. Situated on Bridge Street, just a few minutes stroll from the Four Courts in Dublin, it is said to date back to 1198.

The National Museum of Ireland has since verified that Sean's Bar is older, and it was also awarded the Guinness World Record for Oldest Pub in Ireland in 2004. However, the proprietor of The Brazen Head disputes this, and has asserted that it is the oldest pub in the country as it has operated under the same name since the 18th century. Sean's Bar has changed names over the years – back in the 1700s, it was known as The Three Blackamoor Heads, according to a rental survey. Yet, despite the name changes, Sean's Bar has been operating as a bar for longer than The Brazen Head.

What is not in dispute is that both bars have long-offered a great pint.

In the name of novelty, here's a small list of other bars in Ireland that have novel accolades behind their name:

- Farren's Bar, Malin Head, County Donegal – The Most Northerly Pub in Ireland
- Kruger's Bar, Dunquin, County Kerry – The Most Westerly Pub in Ireland. However, if you're counting the islands of Ireland too, then it's Gielty's Bar on Achill Island, County Mayo.
- O'Sullivan's Bar, Crookhaven, County Cork – The Most Southerly Pub in Ireland
- The New Quays, Portavogie, County Down – The Most Easterly Pub in Ireland

- Johnnie Fox's Pub, Glencullen, County Dublin – The Highest Altitude Pub in Ireland
- The Harbour Bar, Bray, County Wicklow – The Lowest Altitude Pub in Ireland
- The Dawson Lounge, Dublin 2 – Ireland's Smallest Pub
- The Hole in The Wall, Phoenix Park, Dublin 7 – Ireland's Largest Pub.

If any of these claims turn out to be spurious, just remember, they're great for attracting the tourists.

About Visiting

Sean's Bar and The Brazen Head are both free to visit in Athlone and Dublin respectively. Their opening times will vary depending on day of the week and time of the year.

CRYPTIDS AND CREATURES

THE LOUGH REE MONSTER
Glasson, County Westmeath

On a bright, clear evening in May 1960, three Dublin priests were out mayfly fishing on a boat on Lough Ree, where they had fished many times before. The water on the lake was calm, and they were surprised and horrified to spot just above the surface a weird-looking sea creature headed in the direction of the western shore. Its head was python-like, and they could see the hump of its body about two feet away from its head. They calculated that the length of the creature from top to end of hump was about six feet but that there was more of it underwater.

It was about 75 to 90 metres in the distance, and they watched it for approximately a minute before it fully submerged. One priest had enough time to sketch the creature on the back of an envelope. They went ashore and reported what they had seen, and the legend of the Lough Ree Monster was born. By 28 May, there was an advertised reward in the *Westmeath Independent* of £100 for the capture of the monster, dead or alive.

Word of the monster sighting made its way to the Dublin daily newspapers, then to the British press. Athlone was besieged by phone calls from reporters wanting more information and sightseers arrived on scene, hoping to get a glimpse of the enigma. Anglers appeared from afar for a piece of the action, and the idea of using depth charges to smoke the monster out was thrown around.

With business up, some Athlonians were adamant that the monster's emergence was the best thing to happen to the town for in a long time, and were keen to keep up the game. However, this was not the first sighting of a monster in Lough Ree. In fact, there was an abundance of monster lore, extending back over 1,000 years.

St Mochua of Balla in County Mayo, a 6th-century saint, described in the *Life of Saint Mochua of Balla* how he saw a monster on Lough Ree. A deer was chased onto an island in the lough by a hunting pack, who refused to pursue it across the water because of the presence of an aquatic beast under the waters that was known to eat swimmers. In older sources like these, a creature is called a *píast*, which can mean a dragon or a serpent or a monster.

There were permanently inhabited islands on Lough Ree, known as the Black Islands. One island native reported an odd incident, which happened around 1930. He told of a time he hooked a gigantic fish on a pike line, only for an underwater beast to drag the fishing boat across the lake until it got free of the line.

This is not the only account of an unknown creature

disturbing boats and other animals on the lake before the priests' sighting. Other islanders in February 1960, three months before the priest's sighting, may have encountered the same monster. They claimed that they were netting pike and perch off Hare Island, when they saw some creature stuck in their net heave up a six-foot pillar of water with the strength of a horse. When they pulled in their net, which was only two weeks old, they found a nine-foot long hole in it, and no monster. They didn't tell anyone at the time for fear of being sneered at.

The number of accounts does at least imply that there could have been a large lake animal hassling the land dwellers for decades or centuries. But what then? When the priests gave the account of their close encounter to the Inland Fisheries Trust, they were sure to say that they couldn't be certain that the creature they saw was an unidentified species. They were also adamant, however, that what they saw was not an otter nor a pike nor any other fish that they recognised. They weren't under the impression that it was a floating log either. The authorities deemed the priests to be intelligent, not prone to flights of fancy and credible eyewitnesses.

Locals at the time had a few explanations themselves to account for the monster. One Westmeath county councillor and veteran angler had a good feeling that what they saw was a big pike caught in a pike line. His belief was that it thrashed around and over the surface of the water to escape the line, and this is what the three priests witnessed. Another contemporary hypothesis was that the monster was a family

of otters. When otters travel the pups stay behind their parents in a line, which in water can look like a single long animal cutting through the waves. Somewhere in the mix, the idea that it was a coelacanth came up. Coelacanth are six-foot long fish that can be found off the east coast of Africa and in the waters off Indonesia. They've existed on Earth for hundreds of millions of years, and were thought to be extinct, until someone discovered one in 1938. The recent mystique of this prehistoric fish in 1960 might have got folk excited.

In 2001, an international team of investigators/monster hunters from Norway, Sweden and the USA, came to Lough Ree specifically to investigate the mystery of the Lough Ree Monster. The same team had explored the depths of Loch Ness in Scotland. They spent a week exploring off the shore at Killinure Point, using an underwater listening device called a hydrophone to detect unexplained sonic patterns. They did detect strange underwater noises, but couldn't identify anything for sure.

Team member Jan Sundberg from Sweden asked farmers around Lough Ree about any weird occurrences. Jan was told stories of farmers seeing sheep and cow carcasses with the blood drained from them, and cows being entangled by eel-like beasts on the lake. They were also told of giant lampreys coming up to fishers' boats trying to get onboard.

With this knowledge, Sundberg came to the conclusion that an abnormally big lamprey could have been the Lough Ree Monster. Lamprey are eel-like fish that have a jawless

multi-toothed sucker for a mouth, are carnivorous, parasitic, and sometimes called vampire fish because of how they latch on to other fish to drain their blood and bodily fluid.

Except for the few eager weeks in summer 1960, the Lough Ree Monster has mostly become an obscure legend on the lakeshores (except for the Lough Ree Monster Festival that has been held sporadically in Lanesborough, County Longford), and locals these days might look at you like a humped, python-headed oddity yourself if you ask them about seeing it.

The lake monster sightings of the 1960s remain a mystery to this day. We are no wiser about whether or not it was a vampire fish, an antediluvian living fossil, a load of otters on their merry way, a mythical *píast* of Irish lore or sensationalism caused by the aeronautical engineer, Tim Dansdale, capturing the first purported video footage of the Loch Ness monster only a month before the Lough Ree Monster sighting.

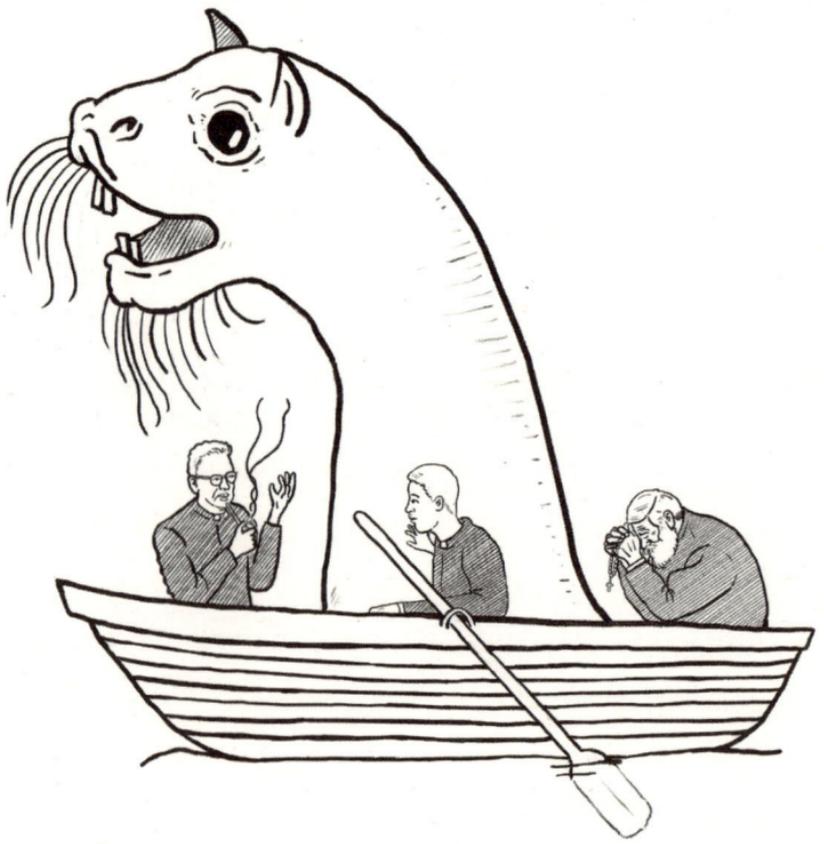

AN PÍAST
The Irish Dragon

In J.R.R. Tolkein's fantasy, *The Hobbit*, the dragon, Smaug, sometimes gets called a worm. Yet Smaug can fly, very unlike an earthworm.

This is actually a neat little holdover from the Old English *wrym* and the Old Norse *ormr* that, today, give us the English-language word 'worm', but that, in the past, were synonymous with 'serpent' or 'dragon'.

Despite Old English and Old Norse being very different from Old Irish, the same symbolism reverberates in the words *píast*, *piast* or *péist*, which can be interpreted as either monster, dragon, serpent or worm. Today, *piast* or *péist* are words in modern Irish for 'earthworm'. Because of these connotations, the mythological creature, which we might today call a 'dragon', in Irish myths are more comparable to a monstrous snake, eel or worm. *Oilliphéist* or *ollphéist* are other Irish words for dragon, serpent or monster, more specifically meaning 'great worm' or 'big worm'.

In particular, the *píast*, or dragon, comes up often in Irish

myths and folktales in the form of a sea serpent or water beast – not unlike our friend the Lough Ree Monster.

In fact, the *píast* and horse eels are similar sounding creatures, but the key difference is that while horse eels are modern cryptids that behave like normal, large fish, *píast*s are much older mythological – almost biblical – beasts that in one story are so huge they can carve the course of rivers using their jaws.

In a similar story, the aforementioned Black Pig's Dyke is called the Worm's Ditch in places because of a story of a monstrous worm drilling the dyke across Ireland instead of a giant boar.

According to legend, both St Patrick and Irish warrior hero Fionn Mac Cumhaill are said to have their run-ins with dragons, both of which take place around Lough Derg in County Donegal.

St Patrick is synonymous with banishing snakes from Ireland. One particularly gigantic *ollphéist* called the *Caoránach* was initially banished to Lough Derg by St Pat. However, when he decided to banish the rest of the snakes from Ireland, the *Caoránach* decided to slither off the island by burrowing its way from Lough Derg to the sea and, in doing so, carved the longest river in Ireland: the Shannon.

An even older tale is that of Fionn Mac Cumhaill. Fionn and his band of warriors, na Fianna, end up accidentally unleashing the monstrous *Caoránach* upon the people living on the shores of Lough Derg. One of the Fianna decided to undo the wrong by leaping inside the monster and slaying

it from within. The blood bled by the beast dyed Lough Derg red, which gave the lake its name from the Irish colour red – *dearg*.

Dragons, like ghosts, are archetypical creatures that appear in stories in almost every part of the world. The American science author Carl Sagan was under the impression that dragons were an instinctive holdover of mammals' fear of dinosaurs, and the Swiss psychologist Carl Jung believed that they are a representation left over from human's reptilian brain further back in the evolutionary ladder. Throughout history and to this day, there are people who postulate that dragons were real creatures that existed on Earth at one time, and maybe still do.

Whatever the reason for dragons being a ubiquitous feature of world folklore, something that is compelling about the Irish version is how here they are normally water dwellers, and how, despite snakes not having lived in Ireland since before there were humans here, these slithering, wriggling, reptilian creatures feature so much in our stories regardless.

FUNGIE
Dingle's Most Feted Former Citizen

In 1984, Paddy Ferriter, the lighthouse keeper at Dingle Harbour, County Kerry, began to notice a single dolphin swimming alongside a fishing boat coming back into the harbour after a day's catch. It wasn't long before the phenomenon known as Fungie became synonymous with the bustling tourist town.

Fungie was a four-metre male bottlenose dolphin who lived in the waters around Dingle Harbour. Naming dolphins is not a common practice in Ireland, but Fungie was no common dolphin. Within a short time of first being sighted, boats were taking tourists out to the harbour so they could see this gregarious sea mammal who demonstrated an atypical fondness for humans.

Dolphins are known to be intelligent and sociable creatures, and for good reason. Studies have shown that they are able to learn, grieve and cooperate with other dolphins, and even with people. There are thousands of dolphins of different

species in Irish waters, and between three to 500 of them are bottlenose dolphins. However, whereas most wild dolphins live in pods, Fungie was solitary. Despite his isolation from other dolphins, he had a rare and natural affinity with humans.

In the 1990s, an almost cult-like following of cold-water swimmers stayed in Dingle to interact with Fungie, some even moving there from abroad. Fungites reported feeling a deep-seated peace when they were swimming with him, and some even claimed his presence had curative powers.

It wasn't long before Fungie-related merchandise and souvenirs were on sale, and even bars and cafes were named after the dolphin. In 2000, a bronze statue of him was erected in his honour in Dingle. He became a national icon, as much a household name as many celebrities, and with a longer career than some.

However, with fame comes controversy, and conspiracy theories abounded about the dolphin. Was Fungie a single dolphin, or any number of dolphins off the Dingle Peninsula that tour guides would give the moniker Fungie whenever one came close enough to a boat to impress the passengers?

Locals are steadfast that Fungie was the one wonderful dolphin over the years. Many Dingle residents talk fondly about about growing up swimming with Fungie, how he would throw fish he'd caught into fishing boats and how he was a resident of the peninsula as much as they were.

His distinctive characteristics also make imposter theory unlikely. That, and the fact that, in 2019, after rigorous

investigations, the *Guinness Book of World Records* awarded Fungie the honour of being officially the longest-recorded solitary dolphin. Bottlenose dolphins can live up to sixty years in the wild, so it's absolutely within the realms of possibility that Fungie was the same dolphin delighting locals and visitors from 1983 until 2020.

But every dolphin has his day. In October 2020, residents grew worried when they hadn't seen Fungie in a week. Experts declared that the lone dolphin had either moved into fresher waters or had died. One year later, the community of Dingle unveiled a new mural to their mascot and old friend and celebrated his life. Whatever his fate, Dingle's beloved dolphin hasn't been seen since.

THE ABHARTACH AND VAMPIRES IN IRELAND
Slaghtaverty, County Derry

Vampires aren't typically considered an Irish mythical being; they are generally associated with southern and eastern Europe. That is until you remember that the basis of modern gothic vampire fiction, *Carmilla* and *Dracula,* are written by Irish authors, Joseph Sheridan Le Fanu and Bram Stoker respectively.

Outside of these, the most prominent vampire story in Ireland is that of the Abhartach. The Abhartach legend was first written down around 1869 in *The Origin and History of Irish Place Names* by Patrick Weston Joyce, though the story was told in its local area long before then.

The grave of the Abhartach is said to be in a townland of Slaghtaverty in north County Derry. The Abhartach was a tyrannical chieftain, a wizard and a dwarf. He was dreaded for tormenting his subjects but, eventually, got his comeuppance when he was slain by another chieftain. In some versions of this story, the chieftain is called Cathán;

in others, it's Fionn Mac Cumhaill. Either way, the Abhartach was killed for the first time and buried standing upright, a courtesy for chieftains at the time.

In a sinister plot twist, the Abhartach made a return from the grave – and he came back with a desperate thirst. He returned as the undead and, to sustain himself, he began feeding on the blood of his former subjects. Fionn Mac Cumhaill gave vanquishing the Abhartach another lash, but the Abhartach came back from the grave a second time. On advice from a saint and/or druid, Fionn obliterated the Abhartach again but, this time, he used a sword made from the wood of a sacred yew tree. He buried the Abhartach upside down, with his chest facing the earth, sprinkled ash twigs on top of the body, and lay a boulder on top for good measure.

To this day in the townland of Slaghtaverty (from the Irish 'Sleacht Ábhartaigh'), you can see a prehistoric cairn next to a hawthorn tree that is alleged to be the grave of the Abhartach, which paradoxically gets called both the Dwarf's Grave and the Giant's Grave. Maybe the dwarf and giant conundrum isn't as important as the word grave, because the undead can't die. The boulder that lies over him is only meant to imprison him, and if it were to be moved the vampirical Abhartach could be unleashed yet again.

One thing that gets brought up a lot in discourse about vampires and Irish folklore is the possible alternative influences that Bram Stoker had when writing *Dracula*. Literary experts and casual readers alike take issue with the

popular belief that Bram Stoker was primarily influenced by the historical figure, Vlad the Impaler. There are lots of interesting hypotheses out there, one of them being that Bram Stoker was inspired by stories told by his mother, who had lived through a cholera outbreak in Sligo in 1832. Fans of that particular theory read it as the character Dracula being the personification of cholera. The 14-year-old Charlotte Thornley, who later became Bram Stoker's mother, would have seen smoke-filled air from tar barrels left to burn on the streets to cleanse the air of plague. She would have witnessed the hospital grounds littered with corpses and mass graves filled with bodies because carpenters couldn't keep up with the demand for coffins. According to some stories, certain poor souls were even buried alive because there was so much fear of the spread of sickness.

Is it possible that Charlotte told her son about these events and it set his mind to a dark gothic tale of the undead? Or could the tale of the Abhartach have inspired aspects of *Dracula*? Stranger things have happened.

IRELAND'S TASMANIA
Lambay Island, County Dublin

With all this focus on mythical beasts of yore, it would be easy to overlook the weird occurrences of unexpected creatures that have actually taken up residence on this island. Who would expect, for example, that Ireland would be home to a flourishing wallaby colony?

Wallabies are medium-sized marsupial animals native to Australia and the South Pacific island of New Guinea. Think little kangaroos, with all the cute hopping, twitching noses and pouches nestling tiny joeys. Where you don't expect to find these Australasian marsupials is on a tiny uninhabited island off the coast of Ireland.

And yet mobs of red-necked wallabies – and that's their genuine name – live on Lambay Island, four kilometres off our east coast. Rupert Baring, the owner of the island, first introduced wallabies to Lambay in the 1950s, along with other exotic species. The wallabies thrived, mainly because the climate and environment are conducive and there are no predators

After that, excess wallabies from Dublin Zoo were moved there in the 1980s, and there are now around 100 wallabies living in the wild on the tiny island.

Wallabies are not the first hairy critters to come to Ireland in recent times. Grey squirrels only arrived here in the 20th century, and even rabbits only came here with the Normans in the 12th century. So perhaps it's only a matter of time until we start seeing little wallabies stowing away on a boat from their own colony island and onto the mainland.

BIGFOOT SIGHTINGS IN IRELAND

Bigfoot is probably the most iconic species of cryptid out there. Also called a Sasquatch, Bigfoot is a tall hairy humanoid creature generally associated with North America. However, since the iconic cases of Bigfoot sightings in the USA, such as the Patterson-Gimlin film case in the 1960s – in which a purported Bigfoot, walking in the woods, turns to the camera – sightings of the giant ape-man cryptid have gone global.

There's one problem. Many regions of North America are covered in expansive and sparsely inhabited forestry, giving an elusive species of creature plenty of habitat to go about its business. Ireland on the other hand has about 11 per cent tree cover and most of the land is deforested farmland. Not such easy terrain for a Bigfoot to hide, but Irish Bigfoot sightings are made, nonetheless.

A video of a purported Bigfoot sighting at Blessington, County Wicklow in 2012 shows a shadowy figure moving with ease just beyond a tree line.

One woman reported a sighting in 2017, during a walk

in Slieveanorra Forest, County Antrim. A photograph she took of her dog had a mysterious figure in the background, which some people believed to be Bigfoot.

In 2020, mysterious large, clawed footprints were spotted in the Phoenix Park, Dublin, that could not be identified. The Irish Bigfoot Research Organisation (IBRO) deemed this unusual because such sightings are atypical in Dublin, being more prevalent in the Wicklow Mountains or further north.

The IBRO reports that Bigfoot can vocalise in a high-pitched whine, like that of a donkey. They can grow to eight or nine feet tall, and have dark hair.

There have been sightings of more than one type of Bigfoot in Ireland. There's a skinny type that can be seen nimbly roaming bog lands and another called a wildman, which is a neanderthal-looking Bigfoot. Sometimes, an Irish Bigfoot gets called a *Gruagach*, which translates as 'hairy thing'.

Irish Bigfoots have been reported by the IBRO to build wooden stick structures in forested areas. A tree turned upside down is said to be a Bigfoot territorial marker. All over the world, Bigfoot sightings are known to coincide with strange electrical disturbances. Lights flickering on a car, radios turning on and off, for example. Gifting is another behaviour exhibited by Bigfoots. This activity can work in either direction, with a Bigfoot accepting or receiving gifts, normally food. The IBRO believe that the gifting behaviour may indicate that Bigfoot is an intelligent creature because of how it attempts to interact with humans, whilst the electronic

glitching that can come with their presence may show them to be otherworldly beings.

Despite there being no direct evidence of Bigfoot in Ireland those accounts and hypotheses are fascinating enough to merit a fun night camping in the woods with torches and a camera – just in case …

FLYING SAUCERS OVER IRELAND

For millennia, people have looked up to the skies, wondering what mysteries they contain. The concept of an otherworldly alien species and the sighting of unidentified objects are not recent phenomena, and have long gripped the imagination of many.

Like Bigfoot, aliens and unidentified flying objects (UFOs) have a bigger association with North America than Ireland. In the 1940s and 1950s, UFO sightings became a national sensation there, most notably with the alleged crash of a UFO in Roswell, New Mexico, in 1947, and the release of 'flying saucer' films like *The Day the Earth Stood Still* in 1951.

UFO sightings globally number into the hundreds of thousands, with a decent chunk in the skies over Ireland. Over the past few years, there have been dozens of UFO and alien sightings around the country. In 2016, a man reported meeting a tall, grey, naked creature in County Antrim. Fast-moving bright lights seen off the southwest coast of Ireland were investigated by the Irish Aviation Authority in 2018. In 2021, a spaceship-like object with

flashing lights was spotted around Downpatrick, County Down, as was an odd-shaped disc in the skies around Slemish in County Antrim. A triangular object with fire-coloured light on each point was sighted in the sky of Ballymahon, County Longford, in 2023. Most recently, in County Cavan in January 2024, bright lights were seen moving across the night sky.

Numerous groups over the years have dedicated themselves to documenting and researching UFO sightings in Ireland, including UFO and Paranormal Research Ireland, the UFO Society of Ireland and the Northern Ireland UFO Society. Trinity College, Dublin even got in on the action in 2023, when their researchers teamed up with colleagues in Sweden to search for signatures of past or present extraterrestrial life. They did this using a radio telescope in Birr, County Offaly, and another in Sweden to search for technosignatures, or any signs of other civilisations using technology, like radio signals from aliens.

Some UFO watchers in Ireland claim that UFO sightings are recorded as far back as the early Middle Ages with a particular reference in the *Annals of the Four Masters* from mid-8th century, which recounted: 'Ships with their crews, were plainly seen in the sky this year.' This description has since been dubbed the 'Airship of Clonmacnoise'.

So, what are all these unexplained flying objects? In the case of the Cavan 2024 sightings, it was reportably the Starlink satellites launching, and the County Down footage has all the traits of space debris burning up in the atmosphere.

There are no conclusive explanations for the other cases mentioned, however, aircraft, satellites, shooting stars, space debris and fuzzy-video footage are all viable rationale.

Whether it's meteorites, aurora borealis or aliens from Planet X, there is a decent chance that you'll see some kind of show if you look up long enough at the sky.

FAIRY FORTS

If you've grown up in Ireland, chances are you won't have escaped childhood without being introduced to fairy-fort lore. Whatever you do, you'd better not chop down a tree on a fairy fort, demolish a hillock to construct a bypass or do anything else to your land that would cause the fairies that reside there to take offence. You never know, you might get lost on your way home never to be found again, or subject to some other fairy-decreed misfortune.

Fairy forts are essentially circular earthen mounds in fields that resemble small hills. They often have trees growing on top of them, usually of the whitethorn species. Fairy forts are typically ringforts, which are circular raised settlement enclosures that were built from the Iron Age until the Middle Ages, and are the most common built artefact in Ireland. Ringfort remnants number in the tens of thousands, with an average of one every two square kilometres across the island.

Some of the ringforts show signs of human habitation, some were animal enclosures, and some might have been fortresses for defence. They are commonly understood to be

strongholds for fairy folk and this is why so many of these geographical structures remain undisturbed to this day. If they're on farmland, most farmers won't touch them.

Fairies are said to live in and around fairy forts, although they have the ability to turn invisible, and not everyone has the ability to see them even when they make themselves visible. These fairies have been given a whole host of different names, including the *sídhe, aos sí, na daoine maithe* – and all of these refer to fairies as a collective, not unlike the Borg in *Star Trek*.

One ancient story about these fairies is that they are descendants of the Tuatha Dé Danann who, according to the 12th-century text collection, *The Book of Invasions*, were a magical race of folk or god-like entities that existed before humans. In this origin story, fairies were forced to live underground by the humans who came to inhabit the island. They dwell below the surface, but sometimes linger around surface spots like fairy forts.

Fairy belief may be less prominent now than in previous centuries, where many folk in the 19th and 20th centuries may have blamed misfortunes in their life – like diseased animals or poor harvest – on the fairies. However, as recently as 2017, great carnage was wreaked upon rural County Kerry, when the N22 roadway, which goes from Cork City to Killarney Town, began to suffer from dangerous dips suddenly appearing in the tarmac. The County Council road department concluded that the dips were caused by deep subsoil issues. However, some members of the public, along

with prominent politicians in the area, believed that disgruntled fairies were causing this havoc, claiming that standing stones, burial mounds and fairy forts had been disturbed during the road's construction.

Today, fairy lore is sometimes appreciated fondly, other times it's ridiculed. Whatever way you view it, these stories about mischievous fairies and their dwelling places are part of the heritage of the countryside, continuing a long tradition that represents people's desire to explain the mysteries of the world around them.

PECULIAR
HAPPENINGS

THE SUMMER OF
THE MOVING MARYS
Ballinspittle, County Cork

It's the summer of 1985. Most of the world is glued to the Live Aid concert, where Led Zeppelin triumphantly reunite six years after their break-up, Queen put on one of the greatest live performances ever recorded, and Phil Collins flies five hours to play in London and Philadelphia at the same concert. That same summer in Ireland, performances of a very different nature were in the spotlight, as people witnessed stone statues of Mary, mother of Jesus, do the incredible and actually move.

It all started in Ballinspittle, County Cork. On the evening of 22 July, a local woman was saying a decade of the rosary in front of the statue of the Virgin Mary in the grotto of Our Lady. She looked up from prayer and saw the statue move in an almost human-like way, as if it was breathing or sighing. Her two daughters and neighbours were with her and claimed they witnessed the statue's hands moving.

The woman immediately reported this to the grotto's

81

caretaker's son, who himself then saw the statue move. Word quickly spread of the miraculous sightings, and crowds and TV cameras descended on this tiny West Cork village. It was thought that the statue was most keen to move at twilight, and each evening, hundreds of eager pilgrims gathered to catch a glimpse of any miraculous movement. A festival atmosphere took hold. Business was booming. Chip vans took advantage of the footfall, keeping the crowds fed with their newly named 'grotto burgers'. This unexpected upturn in visitors to Ballinspittle meant improvements had to be made to the infrastructure. New paths, long needed, were quickly laid. Public toilets and phone boxes were installed.

Far from everyone who went to Ballinspittle was pious or superstitious. Plenty of sceptics and non-believers went to have a gawk, and many conceded that they did actually see the statue move, even if they didn't put it down to divine intervention.

Despite there being several television cameras on site throughout the phenomenon, none managed to capture the movement, although some camera operators reported seeing the statue move with their own eyes. Most people reported seeing the statue sway like it was going to fall over. Another common vision was people seeing a man's face superimposed over that of Mary. One man described it as being that of Padre Pio, another claimed it was that of Pope John Paul II. Miracle healing was reported too, including a woman who supposedly regained her hearing, another who lost the need

of her walking stick and a man who had been partially paralysed by a stroke, walked away healed.

The moving statue at Ballinspittle was not the first reported in Ireland that year, nor the last. In nearby County Kerry, in the towns of Asdee and Castledesmond, schoolchildren saw a statue of Christ and Mary move on Valentine's Day, 1985. This was reported in the national news at the time.

What stands out about the Ballinspittle moving statue sighting over that of Asdee is that Ballinspittle was the catalyst that precipitated moving-statue sightings across Ireland for the rest of summer 1985, with camera crews scrambling up and down the country to report the phenomenon. Moving Marys were sighted in counties Sligo, Wicklow and Kilkenny.

Interestingly, one group not on board with the moving statues of Mary sensation was the Catholic Church. Bishops in particular took up the official position of cautious scepticism. Most chose not to visit the Ballinspittle Grotto.

The spectacle that entertained Ireland during summer 1985 came to a crushing halt in October that year, when three men pulled up in front of the grotto in their Mazda. Two got out and quickly made their way up the small hill, and smashed the statue apart with blows from a hatchet, a nail bar and a lump hammer. A crowd of about thirty people watched below in shock. The offenders then made a swift exit in the waiting getaway car. They were subsequently arrested and tried, where they claimed that they destroyed the statue as it was a form of idolatry. The statue was repaired, but was never seen to move again.

There have been holy apparitions since then, but fewer and on much smaller scales. Summer 1985 may have been the last time such a sensation could happen. The decline of the influence of the Catholic Church and the growth of digital technology mean it would be much easier to disprove any claim of miraculous moving statues. Not to mention that there are far more distractions now that we don't need to be staring at stone figures to occupy ourselves. Still, the weird events of that summer would have been something to be a part of, and I for one would be up for a spot of statue watching and a grotto burger on a warm summer evening.

THE HOLY STUMP OF RATHKEALE

Rathkeale, County Limerick

In July 2009, workmen were felling a few trees on the grounds of Holy Mary Parish Church in Rathkeale, County Limerick. When one of them cut through the branch at a vertical angle, another thought he could see a pattern shaped like the figure of a woman in the rings of the tree stump. On closer inspection, he reckoned it to be that of the Virgin Mary holding baby Jesus. Not all the workmen were convinced by the apparition. The man who made the actual cut claimed all he could see was the grain of the tree.

That night, around a hundred local people came to see Our Lady in the tree stump and pray and light candles. Soon, thousands of pilgrims and tourists flocked to the holy stump of Rathkeale to pray and witness the miraculous apparition for themselves.

A petition to keep the stump where it fell was started. The Catholic Church's response was one of predictable scepticism, with the parish priest of Rathkeale claiming that

it was just a tree, and warning that worshipping a tree could count as idolatry.

In keeping with the moving Mary statue, the holy stump of Rathkeale also appeared during hard times of recession and high unemployment. This wasn't all they had in common, as the holy stump also came to its end with an act of vandalism. In August of the same year, the stump was found covered in blue and silver paint, obscuring the alleged silhouette of Mary. The culprits were never found, and the stump was cleaned so that the outline was once again visible. By that point, the buzz behind the stump had died down, and, gradually, the worshippers dwindled to only a dedicated few. It is still possible to visit the holy stump on the church grounds.

THE ALL-IRELAND POC FADA CHAMPIONSHIP
Cooley Mountains, County Louth

The same hill of County Louth where Cú Chulainn practised his skill with the hurl and sliotar in days of lore is now the site of an annual sporting tournament for elite hurling and camogie players.

Hurling has been played in one form or another in Ireland for at least 3,000 years. It was only in 1960 that the Poc Fada Championships were dreamt up by a Dundalk priest. 'Poc Fada' is pronounced 'puck fodda' and translates to 'long puck' – the long hit of a sliotar off a hurley.

What makes the Poc Fada one of Ireland's weirdest tournaments is its course. Competitors must traverse an unpaved five-kilometre course across the Cooley Mountains. It's not a race – the object of the Poc Fada is to cross the course in as few pucks as possible. Players come from across the island to test their skills in one of the most unusual sporting events in Ireland.

It is said that the origin of the Poc Fada was influenced

by old stories from the Táin Bó Cuailnge, which see Cú Chulainn running from Dundalk to Navan Fort across the Cooley Mountains, pucking his sliotar ahead of him and sprinting to catch up with it the entire way. Some competitors may have even surpassed the mythic warrior by now, with the record for fewest pucks to completion being 48 in hurling, and 27 for the shorter camogie course.

Traditionally, goalies were the best competitors at the Poc Fada, as a goalie has to puck the ball far up the pitch in a game of hurling, however non-goalie players have upped their game and excel now too.

The most remarkable thing about the Poc Fada is the sheer spectacle and novelty of the occasion. When and where else are you going to see hundreds of people watching players whack small balls across a mountain range with sticks? Only during the August bank holiday weekend at the All-Ireland Poc Fada Championship in the Cooley Mountains.

THE HAUNTING
OF LOFTUS HALL
Hook Peninsula, County Wexford

Loftus Hall has gone through many incarnations over the centuries. It's been a hotel, a nunnery, a derelict building, a manor house, a haunted mansion and, most memorably, the devil's digs.

The house dates from the 19th century, however there's been an estate on the land since the 12th century. This impressive 22-bedroom house sits on a 26-hectare estate with its own private beach, and received its current name when the Loftus family went to live there after the Cromwellian invasion in the 17th century.

Devilish, haunting tales stem from the mid-18th century. One night around 1750, when Charles Tottenham was the owner of Loftus Hall, a flurry of loud knocks was heard at the front door. A servant opened the door to a young, handsome, storm-drenched man. The stranger's ship had run aground on the peninsula, so he had valiantly made his way to the nearest house seeking sanctuary from the storm.

The family took pity on the land-stuck sailor and invited him to stay until the bad weather passed. The seaman was rather charming and the family took a liking to him, in particular Charles' daughter, Anne. One evening, when they were playing cards around the table, somebody accidently dropped a card, which Anne bent down to pick up. She glimpsed the visitor's feet, which, to her horror, were cloven hooves. She got a shocking fright, because unless the man staying with them was a faun or a satyr, the only other possible conclusion was that he was the devil himself.

When Anne made her discovery, the devil burst into flames and shot up and out through the ceiling of the hall. The ceiling has been fixed since then, but it'll never be the same again.

This wicked unearthing perturbed Anne so profoundly that she spent the rest of her life in a room in Loftus Hall, hunched over with her knees tucked under her chin. When she died, the family had to bury her in a domed tomb because they couldn't reshape her corpse from the fetal position to lie it flat.

From the 18th-century onwards, Loftus Hall has been haunted by the ghost of Anne, along with the devil. At least that's how the story goes. Despite the family living in Loftus Hall being Protestants, they called on a local Catholic priest to exorcise the house of the evil spirits. It seems that he was unsuccessful because paranormal activity has been reported in Loftus Hall in recent years. After 2011, tourists were allowed to visit the house to attempt to communicate with

the supernatural. There was even a ghost log for guests to document any weird encounters they had – these have included guests feeling weight on top of them in bed at night, unexplained cold spots, strange knocks and whispers when there's no one there, and a ghost girl walking through locked doors and into wardrobes. In 2014, one photograph purports to have captured a phantom in the image of a human spirit standing at the doorway. It certainly makes for spooky viewing.

Loftus Hall has changed use a number of times in the past century, and, by the looks of it, is set to reopen as a hotel under a new name. Unless they hire a super exorcist, they're probably not shaking the haunted reputation for a while yet.

IRELAND'S LAS VEGAS OF APPARITIONS
Knock, County Mayo

Walking around the streets of Knock in County Mayo, you'd be forgiven for thinking you have stumbled upon a rock concert. Buses trundling down narrow streets, packed with fervent fans from far and wide, vendors selling gaudy trinkets on every street, a 10,000-capacity venue filling out for the evening's main event. The only thing is, it's not a Springsteen gig – it's mass at Knock Basilica.

Knock was a quintessential small Irish village until the Virgin Mary appeared there one night and turned it into Ireland's Las Vegas of Apparitions.

On the evening of 21 August 1879, two women reported seeing the Virgin Mary, as well as St Joseph and St John the Evangelist, hanging out together at the gable wall of the parish church. The vision lasted two hours, and many others in the village that night also witnessed it. It wasn't long before pilgrims began arriving from afar to the site of the vision. Ten days after the apparition, a 12-year-old girl, who suffered

from deafness and severe ear pain, touched a stone at the apparition site and made the sign of the cross, and was cured immediately. Hundreds of people visiting the shrine have since claimed to having been cured of afflictions such as blindness, paralysis and tumours.

If the Knock Apparition happened today, there would cries of hoax because there would be any number of ways to fake a ghostly figure on a wall, but surely not in 1879? Surely it must have been the real deal given that there were so many onlookers and considering the length of the time the apparition was visible? Well, it turns out there was a method at the time that could have projected such an image, and it's called a magic lantern.

Despite the whimsical name, a magic lantern is a very real scientific device. It's a gadget that dates back to the 17th century and uses a light source, a lens, and small image slides to project static images to a much greater size on a dark background. Magic lanterns set the basis for film projection that we have today and, in 1879, were a relatively common thing.

Reports said the apparitions were like images, insofar as they didn't speak and were totally motionless. Many eyewitness accounts say that it was a dark evening, and the figures of Mary, Joseph and John were brightly illuminated. One woman went to kiss the feet of the Virgin Mary, only to find that they were without substance.

It's not surprising that investigations since the Knock apparition have speculated that the holy figures were projected

by someone nearby with a magic lantern, though exactly who and why remains unknown.

In any case, whether it was a divine appearance or a messer with an old-timey film projector, Knock is one of Ireland's most important tourist attractions with one million tourists and pilgrims visiting the town every year. Aside from the original parish church where the vision was witnessed, Knock now has a chapel dedicated to the apparition with the saints' likenesses depicted in statues, and a modern basilica.

Perhaps the greatest miracle of Knock was the vision of local Monsignor James Horan, whose mission was to build an international airport on this boggy, foggy bit of hill. Knock Airport (now Ireland West Airport) opened in 1986 and carries over 800,000 passengers to the West of Ireland annually. So iconic is this airport that Christy Moore even wrote a tune – 'The Knock Song' – about it.

Makes you wonder – is every rural village just one apparition away from a million tourists a year? An international airport? Or, best of all, a Christy Moore number?

COONEEN GHOST HOUSE
Brookborough, County Fermanagh

In 1913, a quiet, isolated spot in Fermanagh was transformed into a terrifying scene straight out of a horror film. To this day, it is still considered to be right up the top of the list of Ireland's most haunted places, and also the scene of one of the very few exorcisms performed in this country.

The story goes that Bridget Murphy lived in a mountainside cottage near Fivemiletown, Brookborough, with her son and six daughters. Her husband had died several years before in a freak work accident. One day, there was a knock at the door. When one of the family went to check, there was no one there. Maybe it was a bold local child trying to wind up the occupants of the house? They left it, but a knock came again and, when the door was checked, there was still no sign of anyone.

Soon the sounds of knocking and banging were heard all over the house. The terrified residents thought they could hear footsteps in the attic but, on investigation, there was no one up there. Pots and pans started flying across rooms,

the bed levitated a few centimetres off the floor and the sheets in the bed lifted, as if there was a person underneath them, breathing. This wasn't just any old ghost, it seemed, but a much more petrifying paranormal entity – a poltergeist. A poltergeist is a species of spirit that does not manifest itself as a visible entity, but can interact with its environment, normally by throwing objects around the place, moving furniture and the like, and scaring the absolute wits out of its poor victims.

The events got so dire that the neighbours were brought in to confirm the paranormal occurrences and, thereafter, the local priest was summoned. Father Coyle came to cleanse the house, along with a local politician who also witnessed the fantastic happenings. Father Coyle asked the poltergeist questions in Irish and in Latin. The priest asked the phantom to bang a number of times for yes, and it obliged. He asked the entity to cast the dog out from under the bed, and out the poor dog came with a toss. The cleric performed two exorcisms, but to no avail. The poltergeist activity worsened.

These events were well documented in the newspapers of the time, though, naturally, a lot of folk didn't buy the fantastical story. Rumours abounded that all, or some, of the family were behind the noises, or that a family member was into black magic and had conjured a ghoul of their own accord.

The family had enough of ghostly goings on and the associated rumours, and fled their mountain cottage for America. However, the story goes that the poltergeist followed

them. The racket coming from the Murphy's ship cabin was enough to cause the other passengers to complain to the captain who, though disturbed because of his seaman superstition, allowed the family passage to the New World.

Not much is known about the family after that, although it is said that one of the daughters lived in an asylum most of her life because of the trauma from the ghostly ordeal, though other sources say the poltergeist eventually left them alone over there.

The Murphys' house has remained abandoned since their departure, boarded up and surrounded by a fence to keep out keen ghost hunters. More recently, there have been calls to turn it into a tourist attraction and restore it to how it was in 1913 as a museum of country life and to capitalise on the haunting story by installing CCTV to capture any paranormal activity.

Paranormal investigators have visited the house several times over the decades and have claimed to sense a foreboding presence there. Local stories claim that a former dweller either committed suicide or was murdered there prior to the Murphy family moving in, which could explain the haunting.

It's said that nine out of every ten real-life haunting cases aren't convincing – unless you're very keen to believe in ghosts. Then there's that one-in-ten case like the Cooneen Ghost House that's hard to disbelieve.

IRISH STICK FIGHTING

China has kung fu, Japan has karate, Korea has taekwondo, and Ireland has stick fighting. Stick fighting, also called *bataireacht*, or just *bata*, is a martial art indigenous to Ireland that uses a wooden stick, or shillelagh, for self-defense and combat. The village of Shillelagh in County Wicklow has a strong tradition of producing the cudgels – a carved stick made from blackthorn, oak, hazel or any other hard wood. It is normally around four feet long – although a good measure is from the length of your waist to the ground – with a knob on the top like a walking stick. Surprisingly, they're not heavy, considering their size.

Despite being a native Irish martial art, dating as far back as the Iron Age, many people have never heard of stick fighting. It was nearly a forgotten practice, with shillelaghs being repurposed as walking sticks. It was also common to see these sticks sold as souvenirs or as lucky charms. In recent years, however, the practice has wound its way back into consciousness and is now flourishing.

This ancient martial art is not for the faint-hearted, and requires dexterity and agility. Using short, strong jabs, wider

more powerful strikes, blocks, parries, kicks, punches and grapples, stick fighting can be brutal. The thorns on black-thorn cudgels are not removed, and can be used with abrasive effect on an opponent's face.

Although *bataireacht* isn't as well known in Ireland as jiu jitsu, boxing or even fencing, it is experiencing a recent revival. Who knows, in time it could even get its own film franchise, *The Bataireacht Kid*.

THE LISDOONVARNA MATCHMAKING FESTIVAL

Lisdoonvarna, County Clare

In the days before dating apps, single people had to rely on the wisdom of an old man as their dating algorithm. Matchmaking is an old tradition in Ireland that tapered off in the 20th century, whereby a matchmaker helped to arrange marriages between single people in a community. The matchmakers were nearly always older men, and they judged a couple's compatibility based on dowries and class. Grooms were often matched with brides decades younger than themselves.

Matchmaking is almost dead in Ireland now, but if any one place is keeping it alive, it's the town of Lisdoonvarna in County Clare. Lisdoonvarna is famed across Ireland for a few reasons. For one, there's the catchy Christy Moore tune. Then there's the mineral-water baths where Georgian and Victorian gentry 'took the water' to cure ailments ranging from arthritis to skin conditions, and even to detox. Lisdoonvarna also hosted a music festival in the late 1970s

and early 1980s that attracted big names like Van Morrison, Chris de Burgh and Rory Gallagher. It only ran for a few years before it was shut down because locals weren't happy when a Hell's Angels biker gang showed up and caused havoc.

But the short-lived, ill-fated music festival is not why Lisdoonvarna is still a famous brand across Ireland. Every year, for the whole month of September, Lisdoonvarna is flooded with hopeful singles searching for love, craic and novelty. It's the biggest festival of its kind in Europe, and leading the celebrations is the master of ceremonies, the last matchmaker in Ireland, Willie Daly.

Willie Daly is a matchmaker of the old set, learning the trade from his father and grandfather before him. He interviews single people to get a feel for what kind of person they are, then matches them with the person he believes is their perfect partner. Famously, he even carries around a tome, which contains records of the match applications that he himself, his father and his grandfather made. The story goes that the book itself is a lucky charm, and that if you put your match application within it, then place both your hands atop of it for seven seconds, you'll be married within six months. Better yet, do it twice for a greater chance. Sure, it shows that super likes go back further than Tinder. If you're a bit of a commitment-phobe and you want love, but not marriage, then you just use the one hand.

The Lisdoonvarna Matchmaking Festival is still a huge annual event. It just goes to show us that even in this online

world, there is no app that can substitute the thrill of trad tunes in a small bar full of love-hungry singles and an old man with a book like the Sorting Hat from Harry Potter presiding over the occasion.

FOLK CURES
AND
OLD CUSTOMS

SWEATHOUSES

No one today is a stranger to the notion of a steam room or sauna, but it might surprise you to know that, as far back as the 16th century right up until the 19th century, many villages in Ireland boasted little heated houses known as sweathouses, where locals would visit to sit in the nip and sweat out their impurities for half an hour.

This once-common village amenity fell out of favour in the late 1800s and none are in use today. The Leitrim Sweathouse Project has discovered that over a hundred sweathouses were scattered throughout the county. Leitrim is the only county to have carried out such an extensive survey, so there may be many more to be uncovered elsewhere in Ireland.

Far from the luxurious wood-clad saunas of today, the sweathouses of yore were a little more rustic. They were beehive-shaped structures made of stone and sometimes covered in moss or peat to keep as much heat inside as possible. They were only around two metres high, and had just enough room to house two sweaty, naked villagers.

Mystery surrounds the origin of the sweathouses and their

exact function. Few, if any, records were made during the peak years of their use. We still don't know when they came to Ireland, who influenced their origin and whether or not they were used for rituals, such as the ceremonial sweat lodges of some indigenous peoples of the Americas.

One of the things that *is* known about these enigmatic structures is how heat was created. They were filled with turf, which would be left to burn. This created high temperatures inside, and the entrance hole and top hole would be opened to release the smoke but retain the heat. One or more people would enter naked, resealing the entrance hole behind them to give them the best chance of sweating out whatever ailed them, whether it be arthritis, cold, fevers, rheumatism or respiratory illnesses to name but a few. Sometimes, people put burning rushes in them, creating steam and a sauna effect. Often, the sweathouses were constructed near a natural plunge pool where folk could dip themselves in afterwards for a cold shock.

Over time, myths sprouted up about them. It is suggested that they could have been used in rituals or initiation ceremonies where psychedelic material would be burnt to cause a claustrophobic trip of divine proportions.

With the fascination growing about historic sweathouses, and the general interest in the health benefits of saunas, we may yet start seeing small stone huts appearing in fields with queues of shivering, naked cure-seekers waiting to sweat their maladies away in the traditional fashion.

TOBAR NA NGEALT
The Well of the Mad
Gleann na nGealt/
Glannagalt, County Kerry

Wandering around the countryside of Ireland often reminds me of playing a video game. You can dungeon-crawl through abandoned castles, accessorise with your inventory of useful items like maps and torches, and finally take rest in curative places where you can recover your health, magic and stamina, and finally save your progress. Curative places in real life and save points in a video game both require you to go to a specific place and perform a specific action, so your health will be restored.

Tobar na nGealt – or the Well of the Mad if you prefer the anglicised name – is exactly like a save point in a video game. It's in an unassuming spot and you could drive right past it without knowing, if you weren't looking for it. It's in a townland on the Dingle Peninsula in County Kerry called Gleann na nGealt or Glannagalt, which means 'Valley of the Mad' or 'Glen of the Lunatics'. Local legend tells how

Glannagalt got its name. Lunatics from around the country, if left to their own devices, would inevitably gravitate towards that valley by some unknown instinct or magnetism. Those afflicted with madness would drink the water of the well and eat the watercress growing inside it. This little repose would bring them to their senses and they would be magically cured of their mental affliction.

And that's how the fabled cure for madness is said to work at Tobar na nGealt. Hanging on the trees alongside the short path towards the well are clothing, rosary beads, medals and other personal items left by pilgrims as offerings and tokens of thanks. Near Tobar na nGealt is Cloch na nGealt – the Stone of the Mad – which is a large bullaun stone. Locals would keep the hollow in the bullaun stone topped up with milk so people visiting the well could have a drink on their way.

There are a few weird things to note about Tobar na nGealt. Firstly, it isn't actually a well, but a natural stream. Secondly, it's not associated with any saint or holy person, which is pretty much standard for nearly every other curative place in Ireland. Thirdly, it might actually work – a little.

In 2012, a chemical analysis was carried out of its water. Tests showed that it had a higher concentration of lithium than water tested in other parts of the area. Lithium is a chemical element that is used in a lot of medications to treat mental illnesses, including antidepressants. So, maybe there is some basis to this cure, after all.

More lore of Tobar na nGealt tells how a mythological

King of France called Bolcáin went to the well to be cured of his madness after losing a battle at Ventry ... but saying any more would be spoiling the rest of the game. Go finish this playthrough yourself, and make your own adventure to the Well of the Mad in County Kerry.

THE TOMB OF THE JEALOUS MAN AND WOMAN
TRIM, COUNTY MEATH

Warts aren't generally a painful or dangerous affliction, so maybe folk way back were more vain – or wartier – than today because there's some number of wart cures in Irish folk medicine.

Trim, despite being dethroned as the county town of Meath in the 19th century in favour of Navan, is one of the most historic towns in Ireland. There you will find: Trim Castle, one of the largest Norman castles in Ireland; the Yellow Steeple, which is the remains of a 14th-century abbey; the Wellington Monument, a big column dedicated to Arthur Wellesley, the Duke of Wellington, who was raised near Trim; the Cathedral of St Peter and St Paul, which was once one of the largest gothic cathedrals in Ireland; and last, but certainly not least, the Tomb of the Jealous Man and Woman, which is a grave that visitors leave pins on as a cure for warts.

The Tomb of the Jealous Man and Woman lies in the

grounds of a small church next to the ruins of St Peter and St Paul's Cathedral. This sarcophagus-style grave, replete with the effigies of a man and woman lying side by side, is the tomb of Lady Jane Bathe, who died in 1581, and Sir Lucas Dillon, who died in 1593. The story behind the name of the tomb isn't known for sure – but that's far from the weirdest thing about this particular resting place.

Nestled in the crooks and crevices of the tomb are a trove of old rusted pins jumbled with new shiny ones. Locals claim that the key to curing warts is to rub a pin against your wart and leave it in the tomb. Repeat this process for each wart you have, and they will disappear as the pin rusts. Of course, the story goes that if you take one of these pins rather than leaving one, it'll give you warts instead.

ST FAITHLEACH'S WELL
Cullighy, County Roscommon

Ballyleague, perched on the banks of Lough Ree in County Roscommon, is a place where names can be tricky. Ballyleague is often mistakenly called Lanesborogh, because no distance away on the opposite side of a bridge is the town of Lanesborogh, County Longford. Down the road from Ballyleague on the way to Roscommon Town is a curative well with a name that might trip you up if you're not familiar with the Irish language as it was over a thousand years ago, or big into local Gaelic football fixtures: St Faithleach.

St Faithleach (pronounced 'fall-yuh') was the brother of the 6th-century St Brendan, famed for possibly sailing to North America before Christopher Columbus – or Leif Erikson, for that matter. These days, the best-known thing about St Faithleach is the holy well that bears his name. Local legend tells of how the water of the well sprung from the ground where Faithleach stepped off a boat after sailing Lough Ree.

One weird thing about this curative well is that the water

supposedly has two different cures. A cure for stomach ulcers and other related problems is the traditional cure. However, in recent years, the well's curing power has expanded to hay fever and sinus issues. The cure best works by washing your face with the water of the well three times. The water can also be brought away from the well to be used as a cure by someone else. This holy well cure went viral on social media in 2023, reigniting interest and bringing hopeful pollen sufferers to it in droves. The brilliant thing about social media is that it can spread knowledge of these local places and stories that may otherwise be forgotten. It can help ignite the imaginations of future generations, and that is very special indeed.

It goes to show that even in this age of medical and scientific breakthroughs, there is a prevailing interest in traditional cures in Ireland.

THE MAD CHAIR OF DUNANY

Dunany, County Louth

Just finding the Mad Chair of Dunany is a task that could merit a cure for madness by the time you track it down. Situated on an unmarked point on a long stretch of sandy coastline, whether or not you find it is often down to sheer luck. The tide must be out and you must have excellent vision to spot it amongst all the rocks that dot the beach. Often, it can be buried in the sand.

When you do find it, it will cast aside any delusions of grandeur that you may have been holding. A throne-like chair it most certainly is not. To put it bluntly, it's a big lump of a stone that's shaped a bit like a seat.

But don't let that description detract from the lush lore of the Mad Chair of Dunany. It has long been debated as to whether this rock is called the Madman's Chair, Madwoman's Chair or the more genderfluid Mad Chair. To keep things simple, I'm going for Mad Chair here, although the Madwoman's Chair seems to tie in better with the established lore.

The 'madwoman' is said to be a mythological figure called Ana or Áine. She's described as a fairy or a goddess and had a fort on Dunany Point – *dún* being the Irish word for fort, 'Dún Áine' being 'the fort of Ana'.

Dunany Point is a short peninsula jutting out to the Irish Sea. In one story, this coastal outcrop was an attempt by Ana to build a causeway to Britain, but defeated in futility, she sat on a rock on the beach looking out towards the sea until it sent her mad. It is said that if you sit on this chair and you're mad, then it'll cure your madness. However, if you're *not* mad and you sit on it, then it'll send you mad, which seems to be a running theme with Irish folk cures.

I can't tell you for sure whether there is any truth to the Mad Chair of Dunany, but what I can say is that I myself have sat on the Mad Chair of Dunany, and I can't say whether it cured something or did the opposite, which perhaps tells its own story.

OLD IRISH HEADACHE RELIEF
Owning, County Kilkenny

You've had a heavy night down the local and you wake up abruptly because your head is absolutely banging. Which would you rather do?

Scrabble around your bedside drawer for paracetamol, down them with the tepid water you had the good foresight to bring up to bed with you the night before, close your eyes and let the medicine bring sweet relief?

Or . . .

Leave the comfort of your warm, comfy bed, wrestle on your boots and take a trip to a graveyard in County Kilkenny to drink a drop of water from an old outdoor water font?

I think I might know the answer. Luckily, we live in the age of accessible pain relief, but if you were alive before the time of painkillers, you'd have no choice but to grin and bear the

pain or else hold your head all the way to Kilkieran Holy Well.

The well has an outdoor font and a super helpful sign that reads: 'Holy Water Font Cure for Headaches' above it.

If you don't fancy drinking some holy water, there's some even weirder old cures for headaches knocking around.

St Hugh's Headache Stone in County Westmeath cures headaches in a novel manner. The afflicted individual must place their head in a big head-shaped gap in the stone and they'll be cured. The headache stone is a big rock in the back of a field and, as the story goes, a local saint called St Hugh was born on top of it, hitting his head on the stone on the way out and creating a head-shaped gap.

The only catch is that if you use St Hugh's Headache Stone without having a headache, then bad luck will befall you.

Traditional headache cures are plentiful and include:

• Sniffing wild thyme
• Tying paper around your forehead and rubbing vinegar into your temples
• Drinking a strongly made cup of tea
• Measuring your head, followed by praying.

RAGS ON A TREE

On first impression, a rag tree might look like someone was illegally dumping their rubbish and the wind blew the contents of the torn bin bag onto nearby vegetation. However, rag trees are very deliberate and are a tradition centuries older than the invention of the black plastic rubbish bag.

There's a weird custom at many sacred places around Ireland. Whether it be Fr Shanley's Grave in County Westmeath, Tobar na nGealt in County Kerry, St Faithleach's Well in County Roscommon or St Patrick's Well in County Donegal, the trees and bushes adjacent to these shrines will be littered with cloth, clothes and keepsakes from people who have visited. Some say the rags should only be placed on hawthorn trees, but you'll find rags on any species.

In a nutshell, when folk visit one of these places, they often leave a strip of material as an offering. This is doubly the case when they are visiting because they are hoping for a cure for themselves or a loved one, or if they are praying for a loved one, in which case they will likely leave something belonging to that person. Commonly found mementos include inhalers, children's toys, religious medals and beads,

and even face masks. A related practice is leaving coins in revered places, especially in the water of holy wells or on the grave of a holy person.

There is even a small but booming rag-tourism scene where tourists tear up material to tie to the historic places they're visiting to create a connection to the place or to leave their mark there, whether this is a traditionally curative or sacred place or not. This practice, not unlike the trend of fixing locks to bridges in cities, has led to animosity from locals and conventional rag-tree practitioners who find themselves gathering rubbish out of ruins and fields including sweet wrappers stuck to branches, and vape stickers wedged on tree trunks.

One hypothesis about this offering practice is that it comes from pre-Christian rituals of giving sacrifice to nature spirits or deities in their sacred place. Another is that these pre-Christian folk may have specifically worshipped trees and so are offering directly to the tree. Whatever the case, it's not a specifically Irish phenomenon because rag trees can be found in Britain, across Europe and all over the world.

SAMHAIN
An Irish Halloween

When spooky season rolls around every year, we tend to get caught up in the modern manifestation of Halloween to celebrate. Elaborately decorated houses, pumpkin shortages in supermarkets and kids dressing up as superheroes and cadging sweets from neighbours you've ignored for the rest of the year are now standard customs.

But let's not forget that Ireland holds the title of the birthplace of Halloween, thanks to our spiritually aware ancestors, the Celts, who celebrated Samhain (pronounced 's'ow-inn') every November to mark the start of winter. Depending on where you are from in the country, Samhain was first celebrated at Oweynagat Cave in County Roscommon, on the Hill of Ward in County Meath or perhaps somewhere else entirely. For centuries, Samhain was a significant time of year. The festival denoted the end of the harvest season, and the halfway point between the autumnal equinox and winter solstice. There was a belief that the boundary between the mortal and spirit worlds was thinner at Samhain, a concept that became entwined with Christian ideologies.

Since the first Pagan celebrations, centuries of Halloween customs have been passed down through generations and are still followed today. Trick or treating is one such time-honoured custom. During the Samhain festival, people would dress up as fae people, so that the fairies would be indistinguishable from real people for the night. Children used this to their advantage by threatening people with curses until they acceded to their demands. In later years, children would normally sing a song, then be given money or nuts to go on their way. The 'trick' part of trick or treating was rampant on Halloween nights, as young people sought to cause all sorts of mischief by stealing gates from fields, turning signposts the wrong way around or throwing sods of turf at people's roofs to frighten them. Divilment was nearly a duty on that night.

Some of the weirder and more localised Halloween traditions haven't survived the passage of time. These include:

- Determining who will be the first to be married by spinning a knife on a table and seeing who it is pointed at when it stops
- Putting two lit candles over the fireplace to see how they burn. Both are a clear burn? Well, that's good luck for the next year. Dirty smoky burn? Bad luck for the next year. Bit of both? Then both good and bad luck are coming your way
- Leaving bread and milk out on the table on Halloween night as an offering for the spirits of the dead

- Refraining from eating any fruit still on trees after 31 October.

There's too many to list, but one of the spookiest sounding has to be Old Halloween. Over a hundred years ago, Old Halloween was celebrated on 10 November – it's also called St Martin's Eve. One piece of folklore about Old Halloween is that no mill wheel should be turned on that day, because St Martin was killed in a mill wheel. Old Halloween is so named because when the Gregorian calendar replaced the Julian calendar in 1752, it moved the date of Halloween forward by about ten days. On St Martin's Eve/Old Halloween, people would cut the head off a chicken and spill its blood in the four corners of the house. Maybe it's best we don't bring that particular celebration back.

While Halloween is now commonly celebrated in the Western world, there's no doubt that it's been one of the most important festivals in Ireland for centuries.

THE WRENBOYS

The wrenboys (commonly pronounced 'wranboys') used to be an established Christmas tradition in Ireland, particularly along the west coast. It only died down in the second half of the 20th century. Every St Stephen's Day, bands of adults or children would go out dressed in peculiar outfits, to play music and collect money. The outfits worn could vary from straw-hewn rags, animal skins, medieval jester attire or Halloween-esque costumes, marching-band regalia or, for the lazy few, normal clothes. In a way, it was like another Halloween, with the emphasis on the costumes disguising the wearer's identity.

The tradition has its origins in the story of the wren. The gist of this is that St Stephen, a first-century deacon from Judea, was on the run from some soldiers, who were looking to persecute him for blasphemy, and he hid in a bush. A wren flew around the bush, and its chirping gave the jig up to the troopers. He was subsequently executed. And so, revenge was exacted on the traitorous wren every St Stephen's Day, when the wrenboys would chase and kill any wrens that they could find, and carry the dead wrens

on the top of a decorated pole. The wrenboys then went door to door, singing and begging for money. The money that was collected was often put towards a communal shindig after the holiday. This is only one of many stories about the origin of the wrenboys, and celebrations were also conducted in a wide variety of ways, depending on local stories and traditions. In some parts of the country, the wrenboys were called mummers and, in other parts, participants went all out on theatrics.

The wrenboys tradition still goes on in some parts of the country, but nowhere to the extent that it did only decades ago. Carrigkerry in County Limerick is a stronghold for wrenboys, where rather than playing door to door, they play in a public location in the town. One of the reasons for the demise of this centuries-old tradition is because of a familiar problem: public intoxication. Locals had enough of the drinking and disorder that could be associated with the singing, music-playing wrenboys. It's a real shame that this tradition has mostly faded away. The wrenboys were an odd, jovial, and sometimes frightening-looking crowd, but in the pits of winter, the colour and merriment they gave was very welcome.

CULTURAL
EPHEMERA

FOOTBALL SPECIAL AND CAVAN COLA
Ireland's Booming minerals Trade

Ahh! The tastes of a quintessential Irish childhood – Wibbly Wobbly Wonders (frozen-jelly ice pops), Banshee Bones (salt-and-vinegar-flavoured corn snacks) and Mikados (rectangular biscuits topped with marshmallow and jelly). All of these, and more, were unique to Ireland and one of the most iconic of these is Football Special.

This is a soft drink produced by McDaid's Bottling Company, originally located in Ramelton, County Donegal, who have been in business since the 1940s. Soft drinks, or sodas, are often referred to colloquially as 'minerals' in Ireland.

McDaid's company founders were ardent supporters of the local football club, Swilly Rovers FC. The club was so successful in the 1950s and 1960s and won so many tournaments that they began looking for a non-alcoholic alternative to put into the trophy cup. McDaids were soon on the case and invented the Football Cup, which soon was renamed

Football Special. While it has no particular flavour associated with it, folk who give it a go say it tastes like cream soda.

Football Special isn't the only quirky drink by McDaid's. Along with their exotic pineapple soda, cream soda and cola, their second-most popular soda is Smooth Banana, possibly the weirdest-flavoured fizzy drink ever concocted.

Originally, these drinks were only available in Donegal and neighbouring counties, but these days they are becoming more widespread. Despite this growth in popularity, however, most people will look confused if you ask them if they've ever tasted a Football Special or a banana soda.

McDaids are still happily in operation, but other companies haven't been so lucky. Despite a booming trade in the 20th century, the massive global corporations swarmed in to this small island and took over or pushed out indigenous brands.

But let's now take a trip back in time to 1945. World War Two is finally over and neutral Ireland is joyful that life can return to normal after years of worry and rationing. A popular stalwart over the wartime years were fizzy drinks, and most bigger towns had their own bottling company to keep up with demand. Word spread during the war years about a fizzy drink that surpassed the rest – Coca-Cola. With none available in Ireland, Cavan Mineral Water took an entre-preneurial leap of faith and put Cavan Cola into production in 1948. Having no idea what a cola drink actually tasted like didn't stop these ambitious Cavan bottlers: they simply guessed. And so, Cavan Cola was sweeter than your typical cola and tasted like liquorice. It had a foamy

head like porter, and it was sometimes mistaken for a glass of Guinness.

For the time it was around, Cavan Cola was the most popular mineral drink in that part of the country, even outselling Coca-Cola when it eventually became available in Irish shops and pubs. To folk who tasted Cavan Cola before Coca-Cola, the former was the 'original' cola, and the latter didn't taste like cola.

Cavan Mineral Water Ltd was sold to Finches in 1993, and Cavan Cola was phased out by the early 2000s. Despite being out of production for decades now, the drink and its iconic bottle are still fondly remembered by many who enjoyed it.

Dwan's from County Tipperary was another popular producer of soft drinks, famed for their fizzy orange and lemon beverages.

Score Cola was a Cork-produced drink that sold well in that area in the 1990s, but now there is barely any photographic evidence of it ever existing.

These indigenous drink companies excelled in creating drink flavours that are unique to Ireland like rock shandy, red lemonade and brown lemonade. Rock shandy is a cocktail of lemonade, club soda and bitters, with a lemon slice that, these days, is sold commercially as a mix of orange and lemon flavoured fizzy drink. It was created by the former managing director of C&C in the 1950s. Every Sunday, after training with the Blackrock Swimming Club, he and fellow members would go to O'Rourke's pub, and their favourite drink was

this orange/lemon mix. It soon got the name rock shandy in homage to its place of origin.

Although white lemonade is now the predominant colour of lemonade in Ireland, red lemonade was once the star of the lemonade scene. In the 1970s and 1980s TK red lemonade was boss, but there were other brands like Nash's red lemonade knocking around too.

Brown lemonade is an Ulster thing and can still be bought under the brands Maine brown lemonade and C&C brown lemonade. It's said that brown lemonade was invented to give Harland & Wolff shipbuilders something to drink at work that looked like ale after they were banned from drinking booze on the job.

These days, the soft-drinks market in Ireland looks a lot like that anywhere else in the world with the large global brands taking up most of the shelf space. It's difficult not to feel nostalgic for the old days of homegrown fizzy drinks with weird flavours from banana to tangerine, cream soda to liquorice. Maybe it's time to whip up a social-media campaign to bring them back?

HAM-RADIO OPERATORS AND IRISH PIRATE RADIO

What a day! It's the annual day of pilgrimage, Reek Sunday in July, and you've survived the climb up Croagh Patrick in County Mayo, along with hordes of fellow pilgrims. Some have even done it the hard way and climbed it barefoot. Folk don't tend to linger at the summit for too long. However, you do spot the odd person who lingers up there looking preoccupied with a car-radio-type gadget. This person is a ham-radio activator. Ham radios are essentially small amateur radios that are used to communicate non-commercial messages.

To the casual listener, this form of radio might sound like an unappealing cackling cacophony of static and sci-fi-esque beeps yet, in the 1970s and 1980s, it was a huge phenomenon. People would operate ham radios to send transmissions to other operators within a certain transmission radius. Of all the subcultures lurking around today, you wouldn't think that there'd still be folk tinkering with radio signal when they could DM each other. In fact, there are hundreds of them.

This vast subculture has a heap of inside knowledge,

etiquette, rules, technology and activities. To begin ham radioing, you need a radio – some operators will even build their own radio or antenna. Anyone can receive transmissions over amateur-radio frequencies, however you are only allowed to transmit over ham radio when you have passed an exam and attained an amateur-radio licence accredited by the Irish Radio Transmitters Society (IRTS). Ham-radio operators use the military alphabet (a = alpha, b = bravo, etc.). Their radio lingo is extensive and uses numbers and abbreviations, for example, 'seventy-three or seven threes' denotes 'best regards'.

Ham radio operators can transmit from anywhere, be it their house, a vehicle or the great outdoors. Amateur-radio operating can be a competitive sport, a 'radiosport', and there's competitions every weekend of the year. Summits On The Air (SOTA) is a popular ham-radio activity in Ireland. You'll see SOTA ham-radio operators in the wild atop tall hills and mountains attempting to contact other operators. In SOTA, there are two roles: activators, whose job is to transmit from hilltops, and chasers, whose job is to receive transmissions from activators. Transmitters achieve points by completing SOTAs and, with a thousand points, an operator gets the title of a 'Mountain Goat', and this can be a Mountain Goat x2, Mountain Goat x3 or however many times they achieve a thousand points.

You might be wondering why these ham-radio enthusiasts don't make their own radio station. They don't because it's illegal but, before 1989, it was less regulated in Ireland, and pirate radio stations were hugely popular.

Cultural Ephemera

In Ireland, the 1970s and 1980s were the heyday of pirate radio stations. There were hundreds of them broadcasting across the country, although many of these lasted under a year. Irish pirate radio stations had colourful names like Big L, Energy 103, Sunshine 101, Big D Radio, Crystal City Radio, Ozone Radio and Radio Rainbow International. These stations could play a wide range of music from around the world and broadcast local news, like deaths in the parish, before the larger stations could. New legislation enacted in 1989 swiftly pulled the plug on them, but they are fondly remembered and archived extensively online to preserve this unique piece of Irish analogue history.

If the idea of booting up an antique wireless to listen to the inane chatter of truck drivers on the east coast of the US or a windswept stranger perched on the side of a mountain appeals to you, then check out the vibrant scene of ham-radio operating in Ireland. If you're keen to start up your own pirate radio station with your pals, I'm afraid you'll just have to make do with setting up a podcast, like everyone else these days.

WIBBLY WOBBLY WONDERS AND IRISH ICE-CREAM LORE

If I was to tell you that there was an ice pop that has a half strawberry ice cream, half banana ice cream base, with chocolate-covered, frozen lemon jelly on top, you might think it a weird combination. If I were to say it was called a 'Wibbly Wobbly Wonder', I'd understand if you thought it was a wind-up.

That is unless you lived in Ireland between the 1970s and 2000s, in which case you'll likely have enjoyed the popular delicacy on more than one occasion.

The legend behind the pinnacle of all Irish ice pops is that it was dreamt up by someone in the accounts department of HB, the company who produced them, as a money saver for the company. A Wibbly Wobbly Wonder was the same size as a normal ice pop, but because half of it was jelly rather than ice cream, the cost of production was lower.

The Wibbly Wobbly Wonder briefly came back in 2006 to celebrate HB's 80th birthday. Every summer in Ireland

there are sporadic calls from the public to bring it back. Maybe we'll get lucky for HB's 100th anniversary in 2026.

But this is just the tip of the ice-cream berg.

There are unanswered questions surrounding the disappearances of Fat Frogs, Freaky Foots and Zooms, and even Ireland's most popular ice cream has a great mystery behind it.

This soft vanilla ice cream served from a machine into a cone, with a Flake chocolate stuck into it, and optional flavoured syrup, is known in Ireland as a '99'. People commonly believe that this ice cream got its name from its original price of 99 pence. However, this is a misconception. The strong argument against this is that prior to the decimalisation of currency in the UK and Ireland in 1971, it would have been awkward for something to cost 99 pence, as there were 120 pence in the pound. The next unit down was a shilling, which was 12 pence – so eight shillings and three pennies would have been needed to make 99 pence prior to 1971.

The next most-common hypothesis is long-winded, but it's a good story. The Italian King's Guard in the early-20th century consisted of 99 bodyguards, so it became habit to use the phrase 'ninety-nine' to describe anything that's really good – and because so many ice-cream sellers in the UK and Ireland were Italian in the period that soft-serve ice cream became common, they named it the 99.

One fun notion is that 99 in Roman numerals is IC which could stand for 'Ice Cream.' Another hot take is that they

got named 99s simply because shopkeepers thought the name was catchy.

The only consensus is that no hot summer's day in Ireland is complete without having had one.

SHOWBANDS
Ireland's Swinging Sixties

What do you get when you put together countryside dancehalls, rock'n'roll, brass sections, dress suits, Elvis Presley and boots with a nice, thick heel? The answer is the unique Irish phenomenon of the showband.

Showbands could only have happened in Ireland in the mid- to late-20th century. The end of World War Two marked a recovery and boom era in the economy. Young people had a bit more cash and mass-communication through radio and television exploded. Youth culture in Ireland was changing with the times, and while dancehalls remained popular, young people were over the orchestral bands of the 1940s. As new types of music started coming out of the UK and USA, Irish bands realised they had to evolve to include rock'n'roll, folk, country and western, as well as Irish trad. Their performances had to match the new sounds, and they began standing up and moving around the stage – with that shift in energy and sounds, the era of the Irish showbands began.

Some of the biggest groups in the scene included the Royal Showband, the Capitol Showband, the Dixies, Big Tom and

the Mainliners, Joe Dolan and the Drifters, the Miami Showband, Red Hurley and the Nevada Showband. According to estimates, there were well over a thousand showbands active in Ireland during the 1950s and 1960s, with some still going strong until the 1980s.

While UK and US groups focused on releasing albums and getting radio play, showbands were all about life on the road. Their main income was from gigging, so a popular showband could play five nights a week in dance halls around the country. In the 1960s, the influence of the Catholic Church was strong, and it meant that ballrooms couldn't operate during the 40 days of Lent, with the exception of St Patrick's Day. This religious break allowed showbands a chance to tour in the UK, USA and Europe, where they also grew a fanbase.

By their nature, showbands were focused on playing shows rather than releasing records, and so their setlists relied heavily on cover songs from American bands or traditional songs. While music in the late 1960s started adopting an edgier tone, with the whole sex, drugs and rock'n'roll thing, showbands in socially conservative Ireland had a clean-cut, family-friendly look. Looking back at them now, showbands seem as kitsch as a *Star Trek* or *Batman* series from the 1960s, but, even back then, showbands weren't afraid to look silly. A night at the dances was a full show which could include skits or comedy acts. One band, The Indians, even took to the stage dressed in a parody of Native American style, something that would not happen today.

The showbands tapered off in popularity in the 1980s when tastes changed again, but some prevail to this day, playing theatres as part of nostalgic shows. The showband era is one fondly remembered for its bands who showed Ireland how to party.

IRISH RALLY-CAR DRIVING

If you've got the skill and tenacity to drive across the M50 in Friday-evening, rush-hour traffic, dodging hurtling lorries, boy racers and road-rage-fuelled motorists, then you might just have what it takes to participate in one of Ireland's most popular subcultures: rally-car driving.

First introduced in Ireland in the 1930s, its popularity has exploded since then. Rallying, as it's often called, is an on- or off-road motorsport competition using specialised or modified cars. Unlike arena driving, rally driving is often conducted on challenging and winding terrain with varying surface conditions, such as tarmac, dirt, gravel or snow. The races aren't like typical races with a simultan-eous starting time. They tend to take place over a number/successive number of days, and drivers race each other by completing sections in the shortest time. The driver with the shortest overall time over every stage is the winner.

Rallying in Ireland has its own unique challenges because of the notoriously narrow, winding courses over country roads and boreens. Sharp turns, unpredictable gradient changes and blind corners ensure these courses are not for

the faint hearted. This is before we even mention the weather: heavy fog, sunshine, rain, hailstones, you name it – and sometimes all within the space of an hour.

The rally cars themselves are reason enough to get interested in the motorsport. Rally cars are iconically souped-up to have greater suspension and safety on the roads during nerve-wracking races. They're painted in bright colours and kitted out with huge spoilers – the more eye-catching, the better.

Rallies are staged all over the country, but the best known include the Donegal Rally, which begins and ends in Letterkenny, the Rally of the Lakes in County Kerry and the third-oldest rally in the world – the Circuit of Ireland Rally, which begins and ends in Northern Ireland.

If you're looking for an exhilarating way to spend some time, rallying might be the sport for you, either as a spectator or participant. Information on events is easily found online.

FATAL DEVIATION
Ireland's Worst Film?

Fatal Deviation is a 1998 martial-arts film made in and around Trim, County Meath, and is a definite contender for Ireland's worst film – if not the worst film of all time. It was written by, and stars, martial artist and stunt actor James (Jimmy) Bennett. Bennett idolised the action-movie stars of the time, like Steven Seagal and Jean-Claude Van Damme, and he wanted to use this film as a springboard to get himself bigger roles in Hollywood.

To anyone reading who has never seen or even heard of *Fatal Deviation*, I recommend it big time. If you don't have the time or the inclination, I'll give you a brief synopsis of the plot. Our main character, Jimmy Bennett (yes, he goes by his real name in the film) leaves an institution he has been raised in since he was orphaned as a young boy. On returning to his old family home, now dilapidated, he begins doing it up and settling himself back into the town. However, the town is now run by a gang of generic goons who cause hassle for the townsfolk. Bennett has some run-ins with the bad-guy gang and this gets the attention of the gang leader, Loughlan, and his son, Mikey

(played by Mikey Graham of Boyzone fame). After an attempt by the gang to take out Bennett, his love interest, Nicole, is kidnapped and taken to the gang's caravan in a quarry. Bennett trains with a monk to improve his martial-arts skills in the lead up to the Bealtaine Tournament, where he comes face-to-face with the champion of the gang, Seagull. Bennett is victorious in the tournament and finishes off the gang. In the final action-packed scenes, Bennett eliminates the rival gang, including Loughlan and Mikey, rescues Nicola and lives happily ever after.

Sounds fine. A little ridiculous, definitely clichéd, but buck standard and amusing enough. What separates *Fatal Deviation* from your stock 1990s action movie, though, is the particularly wooden acting, the slow pacing, the poor video quality and the cheesy soundtrack. Apart from those negatives, it's thoroughly entertaining, with one of the most iconic scenes featuring Mikey from Boyzone cutting a line of cocaine with a Dunnes Stores card.

Fatal Deviation has clearly earned its cult status not only in Ireland, but internationally too. It stands with the likes of *The Room*, *Troll 2* and *Plan 9 From Outer Space*, as one of the greatest worst films ever made.

However, the purpose of the film was to get its creator Jimmy Bennett bigger acting roles and his ambition was fulfilled in the end. Since the release of *Fatal Deviation*, he has starred in movies alongside his heroes Dolph Lundgren, Randy Couture, Danny Trejo, Jean-Claude Van Damme and Steven Seagal.

'Bad' movies the world over have huge, dedicated cult

fanbases, and *Fatal Deviation* is no different. I still have hopes that the date of 2 May – the day of the Bealtaine Tournament showdown where Jimmy heroically defeats the gang – will be renamed Fatal Deviation Day. When all the film's fans can unite in Trim and watch the film, visit the sights featured and generally celebrate this cult movie.

IRELAND'S FAVOURITE MUSIC
Country and Western

When tourists visit Ireland for the first time, they might have preconceived notions about its music scene. Maybe they picture themselves in a cosy Irish pub, pints of Guinness in hand, listening to the local trad group get the session started with their bodhráns, whistles and fiddles. Maybe some group participation in lively jigs and reels is imagined. And while Irish trad music is a vital cultural scene in Ireland, the biggest music scene is in fact country and western. They're more likely to hear 'Wagon Wheel', '(Is this the Way to) Amarillo?' or 'Take Me Home, Country Roads' in a pub than 'The Auld Triangle', 'The Irish Rover' or 'Whiskey in the Jar'.

It's not too surprising really, as American country-and-western music does have Irish influences. When the Irish emigrated to the USA, they took the traditional music with them and infused it with other genres of Mexican, Cajun and blues to create a unique country sound.

American country music resonated with people here, with

its common themes and familiar storytelling and, ultimately, its rhythm and energy, making it easy to dance to, hence its popularity.

So popular is country music that Ireland's flagship late night talk show, *The Late Late Show*, hosts an annual Country Music Night Special where the audience turns up kitted out in stetsons and cowboy boots, and Ireland's leading country musicians make appearances to celebrate the booming music scene.

However, with great success comes great tragedy, and one of the most tragic events to hit the country-and-western scene on these shores was the Garth Brooks fiasco of 2014. The American country legend was scheduled to play in Croke Park, Ireland's largest sporting venue, in the summer of 2014. Two nights quickly sold out, and because of phenomenal ticket demand, the two nights turned into three, and then five consecutive sold-out nights. Six per cent of the entire population was due to show up at Croke Park in their cowboy attire. However, Dublin City Council would only issue permission to play three nights, which Brooks wouldn't accept, it was all five or nothing. The concerts were cancelled.

On a much smaller scale, country-and-western music festivals are held all over Ireland and attract some of the biggest names on the scene. Every summer, fans congregate at horse shows where they watch equestrian events while listening to live music from the Irish country stars and have a dance in their cowboy gear. The dancing at these festivals

is jiving and line dancing, and attendees dance with such passion that the event organisers sometimes spread talcum powder onto the dance floors to prevent slipping. You'll see folk of all ages at these festivals, but information on them can be hard to come by for the uninitiated.

'Cowboys and Heroes' near Ballinamore, County Leitrim, is one of the more well known of these gatherings, but there are many more that are so underground that there isn't even a dedicated website to market them.

Country and western has been huge in Ireland for decades, and is showing no signs of abating anytime soon. Whether it's out of love of the music or out of curiosity to experience a subculture you're not familiar with, Irish country-and-western festivals are certainly worth a whirl.

IRISH SURFING LORE

In recent years, the Fáilte Ireland team has been working overtime in conveniently carving Ireland into three neat geographical marketing destinations. Along the Irish Sea is 'Ireland's Ancient East' where you can expect old, ruined churches, monasteries, round towers and the *Book of Kells* – and all the other reasons why Ireland is seen as a place of cultural enlightenment.

In 'Ireland's Hidden Heartlands' – the bastion of bucolic charm – anticipate small sleepy villages, rolling green fields and those countryside churches where they never lock the doors.

And along the western seaboard you'll find the 'Wild Atlantic Way' – look out for rugged coastlines, Irish speakers, fishing villages with expensive chowder and lots of surfers. The main surfing sites in the country are to be found on the exposed coastline from Kerry to Donegal, where the surfing is said by many to be some of the best in the world. When did this phenomenal pastime most associated with hunky Antipodeans and laid-back Californians come to these shores?

The answer is – earlier than you might think. Surfing

started gaining in popularity on these shores in the late 1930s, with belly boards being used rather than surfboards. It wasn't until the 1960s that young folk started building their own boards out of fibreglass. Wetsuits were hard to come by too so some early surfers went out in anoraks. In 1966, Ireland's first surf club, the Bray Island Surf Club, was started by intrepid Irish enthusiasts.

Strandhill in County Sligo became an early home to Irish surfers and remains a popular spot to this day. Other well-known surfing spots include Easkey and Mullaghmore in County Sligo, Lahinch in County Clare, Achill Island in County Mayo, Bundoran and Rossnowlagh in County Donegal, and the Dingle Peninsula in County Kerry.

In 1966, a surfer represented Ireland for the first time in the World Surfing Championships in San Diego, California, and, the following year, the first Irish National Surfing Championships took place in Tramore, County Waterford.

Back then, the Irish surfing community was small and deemed peculiar by curious onlookers. Some went so far as to call the guards over concerns that the surfers were in distress in the water. Mullaghmore, in particular, became fabled for its extreme surfing conditions. It was ideal for big-wave surfing, with waves reaching up to 15 metres.

In Ireland, surfing is ideal in any season for experienced surfers and during the summer for newer surfers, but the year-round nature of Irish surfing means that there are communities of surfers who live out of their vehicles along the coastlines, primed to catch the best waves.

THE RIMINI RIDDLE AND IRISH LOST MEDIA

Lost media is any media item that at one time existed, or is rumoured to have existed, but now is either completely destroyed, unable to be found or exists solely in private ownership so that the public cannot view it. It's a big deal on the internet these days. In North America, communities of lost-media hunters scour the internet for lost-media cases to solve and document.

Ireland has its fair share of lost media too, and there is one in particular that derives from the 1990s. The '90s marked a period of Irish television characterised by weirdness. There was the Irish answer to the *Power Rangers*, the *Mystic Knights of Tir na Nog*. There were a lot of puppet shows for kids: *The Morbegs*, Zig and Zag, Dustin the Turkey and Socky on *The Den* with Podge and Rodge catering to adult tastes on *A Scare at Bedtime*.

Almost every early episode of *The Late Late Show* with Gay Byrne from the 1960s is lost. As are the Irish TV dramas *Tolka Row*, *Glenroe* and *The Riordans* – iconic shows that are sadly unavailable for today's public to view. Then, there is *The Rimini Riddle*.

This was a kids' puppet show that aired on RTÉ from 1992 until 1995. It ran for three series and the most alluring aspects of it, over and above other Irish lost-media cases, are the bizarre plot of the show and the slightly terrifying puppets.

The first time you get a glimpse of the puppets in *The Rimini Riddle*, you may get the distinct impression that someone figured out how to film a nightmare, or be reminded of the early days of AI text-to-image/video models.

They're humanoid figures, but with an uncanny exaggerated quality. From the rare clips of *The Rimini Riddle* available, little can be ascertained about the plot. However, viewers have detailed what they remember of the show – it was a puppet soap-opera where children are sent to live with their Aunt Vera after the death of their parents. In their auntie's house, called 'Rimini House', the children find a picture depicting two girls that leads to a fantasy world where the girls from the picture are portrayed by human actors. The house is meant to contain a dark riddle, which involves mysterious deaths.

However, no footage exists of the human actors interacting with the puppets. There's reported to be several complicated plot lines in the show, and even disagreement over whether it was a children's show at all because many viewers say it was too weird and scary for kids.

The background to *Rimini* isn't actually a riddle, though. We know the names of the cast and creators; leads that have been pursued to no fruitful end. After some investigating, it appears the show may exist in the RTÉ archives, however, the price of digitisation is too much to justify releasing it.

Often, however, the fun in lost-media cases isn't the item itself, but in the search. Since the original *Rimini* search began, more footage of *The Rimini Riddle* has been unearthed. In the 1990s, people commonly recorded shows on VHS, so attic searches sometimes unearth wonders, which are subsequently digitised and made available online, to the great delight of an ever-growing cohort of lost media seekers of Ireland's iconic TV past.

IRISH BUTTER LORE

The Butter Roads aren't a tricky, slippery level in *Mario Kart*. It's the name given to the series of roads in Kerry and Cork that dairy farmers have used to transport butter from country farms to Cork City since the 16th century. The butter would then be exported from Cork Harbour to North America and the West Indies. Cork controlled the butter market in the 18th century, and it was by far and away its most profitable product.

Ireland's butter is just as famous abroad now as it was back then. Its quality is world renowned: the inherent creaminess, which is taken for granted here, is appreciated to the extent that it is even used abroad to sweeten coffee in place of milk, cream or sugar. Irish butter is praised for its appealing deep tone of golden yellow, compared to paler varieties. One reason for this is that Irish cows are fed on grass rather than on hay and silage, which is more common in other parts of the world.

Butter – or strictly speaking, the bovine species from which it comes – also finds a place in legend and lore. The famed Black Pig's Dyke is sometimes claimed to be remnants of an

Iron Age barrier to defend cattle against raiders, such was the importance of cows. One of Ireland's most significant legends, Táin Bó Cuailnge, tells of an epic war between two kingdoms of Ireland, waged over a cow in County Louth.

In Cork City, the love and fascination with churned cow's milk takes a new turn in the form of the Butter-Museum. It exhibits not just the historical and current butter-making practices, but also demonstrates the valuable place butter held in household life and the larger Irish economy. The weirdest thing about the museum is that it has a keg with 1,000-year-old bog butter proudly on display.

Bog butter is butter that has been found buried in a bog and is often thousands of years old. Like the phenomenon of bog bodies – where dead bodies would be preserved by the low oxygen levels and temperatures – bog butter is preserved by the conditions in bog peat. The butter is normally found inside a container like animal skin. Another reason why bog butter might have ended up in the ground is as a ritual sacrifice to some kind of deity.

It is no small statement to say that Ireland's true gold is the butter industry. It was known to the Irish since time immemorial and remains one of our biggest exports today.

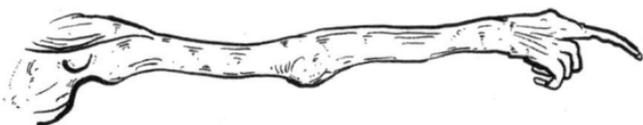

ODD ARTEFACTS

THE CAT AND
RAT MUMMIES
Christ Church Cathedral, Dublin

Christ Church Cathedral in Dublin was originally built under the rule of Hiberno-Norse King Sitriuc Silkenbeard in the 11th century. Richard de Clare, often known as Strongbow, was a 12th-century nobleman who was principally behind the Anglo-Norman invasion of Ireland. Under his reign, Christ Church Cathedral was rebuilt in stone, rather than wood like the original. His tomb is placed in the nave of the cathedral to be revered, or reviled, for his role in the history of Ireland. As years passed, cathedrals were built and rebuilt on this site up until the 19th century.

The weirdest detail about Christ Church Cathedral, however, is that amongst all the beautiful artefacts, religious relics and impressive architectural features, one of its oddest displays are of a mummified cat and rat.

The original Tom and Jerry were found dead inside an organ pipe in the 1850s, possibly from Tom chasing Jerry up the pipe and the pair getting stuck. Perhaps their odd

death is what led to the decision for their remains to be mummified and put on display in the cathedral's crypt. The duo have since been further immortalised, with a mention in one of Ireland's most famous literary works, *Finnegan's Wake* by James Joyce, where a character is described as being 'as stuck as that cat to that mouse in that tube of that Christchurch organ'.

THE WHISPERING DOORWAY OF CLONMACNOISE AND SOUND TOURISM
Clonmacnoise, County Offaly

At first glance, Clonmacnoise seems like your standard ruined monastery. However, weirdness abounds in this 6th-century Christian settlement. There are not many monasteries in the world that can claim to have a whispering doorway.

The doorway of Clonmacnoise Cathedral curves high into the air and has distinctive grooves that can carry a whispered message from one end of the portal to the other. It works like this: one person puts their head into the groove of the archway and whispers something while facing the stone surface. If the other person puts their ear into the groove on the opposite end of the door, they will be able to hear what was whispered.

While it's a fun game to play, folklore tells of a slightly gloomier use for this whispering doorway. Back in the days when leprosy was prevalent, lepers would come up to the doorway and whisper their confessions to the monks.

The mechanics of the doorway meant that monks could hear without being close enough to become infected.

The whispering arch still works and people travel to Clonmacnoise just to give it a go, a phenomenon dubbed 'sound tourism'. Although the Whispering Doorway of Clonmacnoise may not have been the first place where this sonic phenomenon was observed, it could well be the oldest-built structure that features it.

Interestingly, in James Joyce's 1922 magnum opus *Ulysses*, the main character Leopold Bloom makes an off-hand reference to whispering-gallery waves. He imagines how a confession box could be concealing a whispering gallery, which would make confessions audible to someone further away. Was Joyce inspired by the doorway in County Offaly that can carry confessions to someone far away?

ST OLIVER PLUNKETT'S HEAD
Drogheda, County Louth

If you were to wander into St Peter's Church in Drogheda, County Louth, to say a few prayers or the like, just be aware that there's the disembodied head of a 300-year-old bishop who was hanged, drawn, quartered, beatified and canonised, on full display to the left of the altar.

Ireland is no stranger to preserving mummies and skeletal remains, but this strange relic really pushes the boundaries of decent taste, and could only have got there via a story as weird as the thing itself.

Oliver Plunkett was born in Loughcrew, County Meath, in 1625 to a well-off family of landed Catholic gentry. He travelled to Rome in 1647 to train as a priest, where he was ordained and received the title of Father Oliver Plunkett in 1654. He moved back to Ireland in 1670 and set himself up in Drogheda with the new title of Archbishop Oliver Plunkett.

A few years later, Plunkett became a victim of a paranoid

and false conspiracy theory that accused him of collaborating with the French to plan an invasion of England. He was tried for treason in London, and was found guilty. On 1 July 1681, Plunkett met his maker at Tyburn. He was hanged, drawn and quartered: the execution method reserved for traitors. That's where the biography of Oliver Plunkett ends and the legend begins.

After this grim and brutal death, his remains and his reputation follow a wild series of events. His body was buried in London. His decapitated head was dumped into a hole, where it was later recovered and preserved by a friend. His body was exhumed in 1683 and brought to Germany. Long story short, his head and his bones travelled around Europe for many years, before his head ended up with an order of nuns back in Drogheda.

As history played out, he went from being a nearly forgotten figure to an icon of the nationalist struggle in Ireland.

In the 19th century, the process to make him into a saint began and, in 1921, his head was moved to St Peter's Church where it remains on display today. Amazingly, the flesh on his skull is still preserved, though withered and discoloured.

When his head went on public exhibition for the first time, he had a deathly complexion and blank expression. The strangest relic in the country became a hit from that point on, and rumours began to spread that his head had healing properties, and could perform miracles.

As it happens, the rules of canonisation require just that – a confirmed miracle in the name of the would-be saint.

This came in 1958, when a woman in Naples was cured of her illness by a nun praying to Oliver Plunkett on the woman's behalf. And so, in 1975, Oliver Plunkett was sainted, over 300 years after his death.

Oliver Plunkett's head is still on show in St Peter's Church, however, these days, the pilgrims who visited the relic to offer prayers have been replaced by tourists who prefer to take selfies with the shrivelled head.

THE RIDDLE OF THE BOA ISLAND HEADS
Boa Island, County Fermanagh

Boa Island is a long skinny island on Lough Erne in County Fermanagh. It's a quiet, unassuming place so that's why its most famous attraction is so unusual. In the craggy Caldragh graveyard, blended in amongst the 19th-century headstones, stand two jolly stone figures, the Boa Heads.

The larger one is the Dreenan Figure, also known as the Janus Stone. It's 73 centimetres tall, half a metre wide, has big carved eyes, a charming curly moustache and crossed arms. Its Janus Stone moniker is derived from its two-sided face, like the Roman god, Janus. This comparison was famously celebrated in the poem, 'January God' by Seamus Heaney. Standing proudly next to Janus is a shorter figure known as the Lustymore Man, because it was originally found on nearby Lustymore Island, before being rehomed in Caldragh in 1939.

Of all the old stone statues in Ireland, those on Boa Island are among the most mysterious because no one is sure

when they were made, by whom or why. They're not sheela na gigs. They're not cadaver stones, which are corpse-like carvings on the exterior of a grave. Traditionally, it is believed that the Boa Heads were carved during the Iron Age and depict a pre-Christian deity. Another theory is that the figures were made in the Middle Ages by Christians who were incorporating pagan iconography within their idols.

One similar figure to the Boa Island figures is the Tandragee Idol, which was found in the 20th century in a bog in County Armagh. It's a frightening-looking sandstone carving of some kind of creature with goofy, cartoonish eyes and mouth, and two limbs, one crossed over the other, just like the Dreenan Figure. Historians believe the Tandragee Idol was made around 500 BCE, making it more than likely an idol of a pre-Christian deity, which would prove that Iron Age folk did make stone statues of their gods.

Although we can't say for certain that this is what the Boa Island figures are, it doesn't take away from the awesome aura that surrounds them. Whether or not they were revered in the past, they are certainly receiving interest these days, as exhibited by the number of euro and pound coins deposited in a stone gap next to the Dreenan Figure. The Tandragee Idol is now housed in St Patrick's Cathedral in County Armagh, but the Boa Island Heads still stand in the peaceful graveyard down a back road for everyone to come and visit.

ST MICHAN'S MUMMIES

St Michan's Church,
Arran Quay, Dublin 7

What could be weirder than a mummified cat and rat display in a Cathedral? Well, how about a few mummified human bodies casually lying in a vault on Dublin's northside?

Just around the corner from the Four Courts is St Michan's Church, established in 1686. Before that, an 11th-century church stood on the same spot. Almost none of that structure remains, except for some of the vaults underneath the current building. Up until very recently, what lay in the vaults of St Michan's were some of Ireland's most morbid dark-tourism attractions – St Michan's Mummies, a number of named mummified human bodies reposing in open caskets.

The most famous one was the oldest mummy, the Crusader, a shrivelled skeleton around 800 years old. The corpse was over six feet tall, and his legs were crossed to look like a crucifix, which is the way crusaders were historically buried.

Then there was the Nun, at a mere 400 years old, similar in age to the mummy variously known as the Thief or the

Criminal, who got his name because of his missing arm, a common form of punishment for thievery. He was also missing his feet, but that's because coffins were all the same size and he was too tall for his, so they made him shorter in order to fit. However, given that being buried underneath a church was a great honour, and not one befitting a common criminal, it's also suggested that he lost his arms by accident or in battle.

These were natural mummies preserved simply by virtue of vault conditions. The walls are made of limestone, which absorbs humidity and kept the bodies dry. The temperature is consistent all year round, and the soil beneath absorbs methane emitted by corpses. There's a couple of crypts in the vaults of St Michan's with antique coffins that look like something from an old Dracula film. The mummies were on display because of the natural condition and lack of deterioration of their caskets.

Dublin's flagship dark-tourism attraction had seen some nefarious activities over the years. Vandals caused havoc in the vaults in 2019, when the vaults were closed for a time when the Crusader's head was stolen, and the other mummies badly damaged. The head was recovered when the guilty offender left it in a hedgerow in the Church's grounds, alongside a note saying 'sorry RIP'. The perpetrator was caught and was jailed for 28 months, and tours recommenced soon after the head's return.

St Michan's Mummies were up there with other well-known weird attractions of Dublin City, and not without good

reason. It was the only place you were allowed such close and casual proximity with slowly decaying people, and up until a few months ago you were even allowed to touch the Crusader's finger for good luck.

This was until 11 June 2024. That afternoon an arsonist entered the vault of St Michan's and, for some unknown reason, set fire to the mummies. To put out the fire and save the church, the fire brigade flooded the basement with up to a foot of water, sadly destroying any remains contained in the vault, and obliterating any chances of anyone visiting them again.

THE BEEHIVE GRAVE
OF COOKESBOROUGH
Cookesborough, County Westmeath

Once upon a time, there was an estate in County Westmeath called Cookesborough, where the landlord was a man named Aldolphus Cooke. Aldolphus was an oddball, to put it lightly, and held different beliefs about death and the afterlife to many of his Christian contemporaries. Cooke believed, with great conviction, that when he died he would be reincarnated as a fox, and that his father would be reincarnated as a honeybee.

This esoteric sitcom played out in real life in 1835 when Adolphus built a mausoleum for his father on the Cooke estate in the shape of a gigantic stone beehive.

Aldophus Cooke wasn't known as the most eccentric man in County Westmeath for nothing. His unorthodox exploits included frequent military-style drill exercises for servants, and ordering that moss and twigs be gathered and given to jackdaws and crows to make their nests so they wouldn't

make a racket flying about gathering materials themselves. Once, he even commanded that his pet dog be executed by hanging for fraternising with dogs of inferior standing. Luckily for the dog, the execution was interrupted by a turkey cock on the estate who Cooke believed was his grandfather reincarnated. This led to his reasonable assumption that the dog was also a reincarnated ancestor, and so worthy of saving.

Cooke believed that when he was reincarnated as a fox he would be able to evade hunting dogs because of his knowledge of the land of the estate. He wished to be buried in a marble mausoleum there with all his books, a marble throne and have a fire perpetually lit for him.

However, when he died in 1876, he was buried inside the beehive mausoleum alongside his father and Mary Kelly, the nurse who raised him, where the trio rest to this day. That is, unless the reincarnated forms of father and son are, respectively, buzzing around the flowers and stalking through the hedges.

Cookesborough House is now collapsed but in the 1970s and 1980s, on part of the demense a popular disco was run there, aptly named 'The Beehive'.

The beehive tomb is undoubtedly the weirdest and most iconic burial place in County Westmeath, and gives the rest of the island a good run for its money too. These days, it lies in a disused graveyard with a dilapidated church surrounded by farmland. In 2015, restorative work was carried out on the beehive grave by antique stonemasons as

there was a small tree growing out the top that eventually would have destroyed the structure. This weird artefact and the story of its eccentric occupants are worth preserving.

THE ENIGMA OF STANDING STONES

Let me paint you a scenario. Your dog keeps escaping from the garden and your neighbours are fed up of seeing him show up at their door, begging for treats. You put up a fence to stop your dog hassling the locals. Now, imagine it's 5,000 years into the future and you, your dog, your house and your garden, are all gone and forgotten. Of the fence you put up, only one post remains standing. Those future archaeologists wouldn't have too many indicators about what the only remaining fence post used to be. Was it a ritual marker? An ancient gravestone? Part of a measuring mechanism? A boundary marker between lands?

This is a bit like what standing stones are to us now in Ireland. A standing stone is exactly how it sounds: a single big stone standing upright that was placed by people thousands of years ago for some reason or another. I've seen them called 'menhirs', 'liths' and 'orthostats' too, but only ever referred to as standing stones in real life.

They are far from a uniquely Irish artefact and can be found everywhere in the world, however Ireland, Britain and

mainland Europe have the most prominent examples. They were erected over a long period of time; from as far back as the Stone Age until the Iron Age. Although plenty of them are solo standing monoliths, others were once part of a circle or other grouped structure that fell down.

Over the course of millennia, standing stones were erected for diverse uses. It's believed that some were used for burial markers, others as ancient ritual sites and others as land demarcations. Much legend, myth and folklore has sprung up around standing stones with a few standout stories.

The standing stone at Kilnasaggart near Jonesborough in County Armagh is different from other standing stones because it's an inscribed stone. On both faces of the Kilnasaggart Pillar stone are inscriptions in Ogham script, Latin script, and marks of crosses and circles. It dates back to 700 CE, but there is evidence that this stone is on an ancient Pagan site.

Moving south from Kilnasaggart is Clochafarmore in County Louth. Clochafarmore (or 'Cloch an Fhir Mhóir', which simply translates to 'the big man's stone') is an impressive three-metre standing stone situated in a field outside Dundalk Town. It's thought to have been there since the Bronze Age, but as there wasn't much evidence to explain why it was erected, storytellers of yore decided that it marked the spot where Cú Chulainn died – another name for Clochafarmore is Cú Chulainn's Stone. In Irish mythology, Cú Chulainn's death happened after he was tricked into eating roasted dog meat, which drained the energy from one

side of his body, allowing his enemies to take advantage of his weakness and attack him. Cú Chulainn fought back for as long as he could but in his vulnerable state, he could only hold them off for so long. Rather than die lying down, our hero tied himself to a standing stone so he could die on his feet.

The story of Cú Chulainn's Stone is a classic example of how people will attach stories to places and phenomena that are not fully understood. And anyway, as the saying goes, why let the truth get in the way of a good story.

LA TÈNE STONES

There's said to have been a church at Derrykeighan in north County Antrim since the days of St Colman in the 5th century. The ruins of the old church in Derrykeighan aren't quite as old as that but, with all the activity there over the centuries, it's incredible that the Derrykeighan Stone wasn't discovered until 1977.

So what, right? If this book has made anything abundantly clear it's that this island is full of weird old stones. What's so special about this one?

Well, the Derrykeighan Stone is one of only a handful of examples of La Tène Stones in the whole of Ireland. La Tène is the name given to a broad Iron Age culture that would have been found all over Europe. The art of this time is characterised by intricate swirly lines. If you can remember the swan on old one-pence coins, this was drawn in modern La Tène style.

A La Tène stone is a large decorative stone carved with intricate delicate line work. The Derrykeighan Stone, the Castlestrange Stone in County Roscommon, the Killycluggin Stone in County Cavan and the Turoe Stone of County Galway may be the only examples of La Tène stones in Ireland.

Once again, like so many old stones, there's no evidence to indicate what their purpose was. However, what's largely assumed is that they were pre-Christian religious or ritual artefacts. So why was it discovered inside a Christian church built hundreds of years later? It would have been difficult for someone to have put it there – the Derrykeighan Stone is nearly a metre tall and nearly half a metre wide. However, since its discovery this stone, which dates from around 50 CE, has been moved to the Ballymoney Museum in County Antrim. A replica La Tène stone now stands at the old Derrykeighan Church.

Among the odd artefacts of Ireland, the La Tène stones don't get nearly the same fandom as standing stones or stone circles. True, a lot of standing stones and circles are far older, but La Tène stones have a tremendous artistic legacy to them. Since the Celtic Revival of the 19th and 20th centuries, that flowy, elegant self-looping line work that identified La Tène art is commonplace in jewellery, stamps, tattoos, public art, clothes and music-festival art installations.

SHEELA NA GIGS

A sheela na gig is a medieval stone statue or carving depicting a naked female figure displaying its genitalia. They are generally quite small, ranging between 30 and 60 centimetres in height. There are well over 100 of these in Ireland, though they're found in Britain and in mainland Europe too, but to a lesser extent.

No two sheela na gigs are the same. Some have hair on their head, some don't. Some have ears, others don't. They can be standing or squatting. Many have exaggerated sagging breasts, others have one hand on their head with the other opening their vulva, or a hand raised with something indistinguishable in it. The sheelas are so small and worn that it's difficult to know what the item could be – possibly a stone, mirror, fruit or bread.

Sheela na gigs are typically displayed on the outside walls of castles, churches or other prominent buildings in an area. Today, many are held in museums. They've been described as goblin-like and are categorised as 'grotesques' in architectural terms – and with many of them, if you didn't know what you were looking at, you might not guess what they actually are.

There are a few ways of spelling the name, including síle na gig, sheila na gig and síla na gig.

There is also a male equivalent called a sean na gig, but these are much less common. No one's sure why the sheelas were more widespread than the seans, although one hypothesis is that female figures traditionally represented nature for centuries before the carving of the sheela na gigs whereas the sean na gigs did not have this same meaning. Another hypothesis is that male figures were harder to carve than female figures.

Sheela na gigs can be found in almost every county, with a particular concentration of them in County Tipperary. This includes one of the only examples of a sheela placed in a town wall in Fethard. Most Irish sheelas date from between the 12th and 16th centuries, and so are most likely imported ideas from the Anglo-Norman invasion in the 12th century.

Why were people in the Middle Ages drawn to creating these exhibitionist sculptures and planting them in places of public view? What does the sheela na gig symbolise? The truth is, we don't really know. But we do have a few good guesses, ranging from fertility icons, anti-sinning reminders or good-luck charms to occult deities. The fact that they were often positioned on churches also suggests that they were significant to Christianity at the time.

Many of the remaining sheelas are worn from time and natural exposure, and many of the best-preserved examples are displayed in the National Museum of Ireland in Dublin.

Interest in sheela na gigs has exploded in recent years, and

rightly so. They're increasingly viewed as a native Irish symbol of female empowerment and national character, and as a bridge between the old and modern Ireland – one of the great, weird mysteries of the island.

DAN DONNELLY'S ARM

We've already trod in the great Dan Donnelly's footsteps, but it's his arm that makes things take a slightly weirder turn in the story of this legendary boxer.

It's February 1820, and Ireland's greatest boxer of his time, has died and is being buried. There's a crowd of 80,000 mourners lining the streets of Dublin, leading up to his burial place in Bully's Acre, Kilmainham. For most fighters, that'd be the end of the story, but for Dan Donnelly – the King of the Curragh, the Champion of Ireland – it was only the beginning of a macabre post-life career.

Shortly after his burial, Dan was dug up and sold to a surgeon in Dublin for anatomical research. One of two things happened. Either the surgeon copped it was the cadaver of Dan Donnelly and insisted on returning him to his grave or fans of the boxer got wind of what had happened and threatened the surgeon until he put the body back in the grave, or else. Either way, the champion was returned to his resting place, minus his right arm and shoulder blade.

Given his prowess as a boxer, his arm was almost considered

sacred. These days, it would be insured for millions. Rumour had it that it measured three feet in length, and that Dan could fasten the buttons on his knee breeches without bending down.

The arm was preserved to stop it decaying and, after that, it went on a whirlwind tour around the world for over a century. It was believed to have been studied by anatomy students for a number of years, by some accounts at Edinburgh University, before being bought by a curio collector in Belfast.

In 1953, the Kilcullen Boxing Club in the Curragh, just five kilometres from Donnelly's Hollow, held a re-enactment of the famed 1815 Donnelly versus Cooper fight, which got national publicity and attracted a huge crowd now-legendary. The owner of Dan's arm got in touch with the head of the club and arrangements were made for the arm to return to the place of its greatest achievement. It was displayed in the Hideout Bar in Kilcullen for the next 40 years, either in a glass case or mounted on the wall.

Tourists would come from far to see the morbid attraction, until the bar changed hands in the 1990s and the arm got the boot. It has been in a private collection since, but it did go on tour in the 2000s and 2010s to the USA, the Ulster American Folk Park in Omagh, County Tyrone, and the GAA Museum in Croke Park.

These days Dan Donnelly's arm is still in Kilcullen, and has gone on public display during Heritage Week in 2019 and 2023. After more than 200 years, Dan Donnelly's story

still grips the imagination of boxing and history fans the world over. Despite how morbid the idea of a mummified arm on display may be, there are no calls to return it to the grave.

ACHILL-HENGE AND THE FOLLIES OF IRELAND

Achill Island, County Mayo

On a weekend in November 2011, a caravan of articulated trucks pulled up on the west coast of Achill Island in County Mayo and began assembling a 4.5-metre high circular concrete structure resembling Stonehenge in England.

There was no planning permission for this 100-metre-circumference structure. Work began on a Friday and, on the Saturday, Mayo County Council went to the High Court to demand the cessation of construction, but by the Monday it was finished and there is remains to this day, despite a High Court demolition ruling.

Achill-Henge, as the locals started calling it, was built by a property developer from the island named Joe McNamara (no relation), whose most infamous exploit was back in 2010 when he crashed a cement truck, with 'Toxic Bank' painted onto it into the gates of Leinster House, home to the Irish parliament, as a protest against the banks. On another occasion, he

protested from the top of a cherry-picker covered in anti-government and anti-bank messages outside the same buildings.

In response to Mayo County Council's objections, Joe McNamara claimed the cement circle was an ornamental garden for solitude and reflection, and that, as such, it did not require planning permission. In the end, McNamara served three days in prison over the unauthorised building, but the bulldozers never came to take Achill-Henge down. It's never been fully finished either – it was intended to be a roofless agricultural holding with another concrete circle in the centre with solar panels to heat the soil underneath.

In 2011, opinions were more divided on the folly, with some locals furious and others amused. Not long after its erection, it became popular with tourists and locals for its architectural beauty, artistic merit, the boldness of the developer who put it there, and its archaeo-acoustic abilities.

Achill-Henge is designed to reverberate sound across its walls. If someone were to stand in the middle of it and clap their hands the sound would travel all across the structure. Some academics praise Achill-Henge for this feature, claiming that this is how Stonehenge would also have been, when it was first built in around 2500 BCE.

Some folk interpret Achill-Henge as an art project to represent the headstone of the Celtic Tiger, fittingly built from the concrete that dominated Ireland during the building boom of those years.

Achill-Henge can take the title of most bizarre new build in recent Irish history. But think of all the follies constructed

in the 19th century that are now considered marvellous works of beauty. Take the impressive Gothic-inspired Ballysaggartmore Towers in County Waterford, for example. Or the Spire of Lloyd at Kells, County Meath, an inland lighthouse structure that is actually 40 kilometres from the sea. It was built in the 18th century by Earl Thomas Taylour as a memorial to his dad but, these days, folk appreciate it for its beautiful views over the countryside.

This is a great example of how architecture can sometimes be interpreted in different ways by onlookers, often due to the passage of time. A memorial for a lost loved one might be mistaken for an inland lighthouse to someone who is unaware of the historical context. Or a passerby may assume a symbolic grave from centuries ago is actually a giant garden ornament if they haven't done their research. The meanings and purposes behind structures can be lost in history. Who is to say that Achill-Henge will be appreciated in the same way in 200 years' time?

THE PYRAMIDS OF IRELAND

When you think of pyramids, the image that immediately pops into your head is likely of the ones at Giza in Egypt, or – if you're well-travelled – the stepped pyramids in Guatemala or the pyramid temples of Cambodia. But did you know that speckled across Ireland are our own homemade stone pyramids? Built almost 4,000 years after the Egyptians, in the 18th and 19th centuries, these pyramids were also mostly constructed as burial tombs.

The Howard Mausoleum near Arklow, County Wicklow, is one of the best-known examples of an Irish pyramid. In a quiet and otherwise unremarkable cemetery is the grave of Ralph Howard in the shape of a great granite pyramid. This is the final resting place of Ralph and several other members of the Howard dynasty. Viscount Ralph Howard commissioned the pyramid in 1785 and got quick use out of it when he died the following year. The style of the time was to replicate ancient Greek, Roman and Egyptian architecture, and so pyramid tombs were in vogue.

This popular fashion can also be observed not too far off in Baltinglass, County Wicklow, where the Stratford family

must have got wind of the Howard's pyramid and decided to keep up with the Jones's, building their own pyramid in 1832 in Baltinglass Abbey.

This wasn't just a Wicklow phenomenon, however. Up in Garvagh Forest in County Derry, George Canning commissioned his own pyramid on the grounds of his estate after he took a tour of Egypt and was so impressed with what he saw at Giza. This one is a little different in that it's not a mausoleum, because no one was ever buried in it.

In Kinnitty Village, County Offaly, the Bernard family built their own pyramid mausoleum in the 1830s in the village graveyard. I bet that pleased the locals.

The Pyramid of Dublin sitting on the top of Killiney Hill looks like it is influenced by the style of the Mesoamerican pyramids of Mexico and Guatemala as it is a stepped pyramid. This 1852 pyramid is more a folly than a tomb; it's just there to make the estate of Killiney Park look impressive. It's also used as a wishing stone by some locals, as it is said that you can make a wish there by walking around each level of the pyramid going upwards then facing Dalkey Island.

BELLACORICK MUSICAL BRIDGE AND OTHER TUNEFUL ARCHITECTURE

In Bellacorick, in remote north County Mayo, a bridge spans the Owenmore River ('An Abhainn Mhór' means 'the big river'). Nothing too unusual about that, right? But what if I told you that the bridge can be played like a musical instrument? It's unbelievable but true, and so, naturally enough, this bridge gets called the Musical Bridge of Bellacorick. And not only is it musical, but it can be played in two ways.

Method 1
Grab a big stone, lay it flat on the surface of the bridge's north parapet (it won't work on the other side), and run with good speed along the parapet holding the stone hard to the surface. This will give you a loud resonant tone like you would hear sliding up a xylophone.

Method 2

Take the same stone, and tap it on the surface of the parapet with differing levels of force and in different locations for different tones. Did you ever hear one of them steel-drum instruments? It kind of sounds like that.

There are a couple of interesting origin stories behind this bridge, which still isn't fully built and is missing masonry on one end. One morbid hypothesis is that the bridge was built during the famine. During construction, the workers gradually died off from starvation and disease, until there was no one left to finish the last few blocks.

The other story is related to the Mayo Nostradamus, Brian Rua U'Cearbhain. In the 17th century, this Mayo oracle made a series of prophecies about the future of Ireland, including that there'll be a house on every hill, a bridge over every stream and a bridge on the river at Bellacorick that will never be finished.

It's fun to think that there is magic behind Bellacorick's Musical Bridge. However, there is, like most of these things, a rational reason why the bridge makes resonant musical notes. Between every laid block is a groove, and the construction materials also contribute to the music. These notes are octaves glissando when it's the continuous sliding sound (method 1) and octaves staccato when it's the short, sharp, detached sounds (method 2).

The same effect can be heard at the Musical Wall outside Mullingar, County Westmeath. Just in the same way as the

Musical Bridge, people 'play' the Musical Wall by running stones up and down it.

These are just a couple of examples of Irish structures that can play a tune, though, for all we know, there's more to be discovered around the country.

THE RUINS OF OLD IRELAND –
Under New Glass Floors

The jetsam of a 1,500-year-old building boom is still visible all over the island. Here are some stellar examples:

- The ruins of St Mary's Abbey in Trim, County Meath
- The remains of St Cronan's Church in Roscrea, County Tipperary
- The remnants of Saul Monastery outside Downpatrick, County Down.

The building booms of the late-20th and early-21st centuries have uncovered even more flotsam of medieval Ireland. Rather than turning the uncovered sites into museums for the ruins, developers have increasingly come up with clever ways to preserve the archaeological ruins whilst developing the site for modern use.

My personal favourite example of this is in the Lidl on Dublin's Aungier Street. When the Scape development that

houses the Lidl was being built in 2020, archaeologists discovered the ruins of an 11th-century house and the remains of the 18th-century Aungier Theatre and the Longford Street Arches. The Lidl now showcases these relics from the past, with a glass floor over them. So when shoppers are wheeling their trolley to the middle aisle to see what weirdly random items are on offer, they can also survey the wonders of the old Hiberno-Norse suburb below.

This preservation and display of historical ruins isn't reserved for Dublin. In the Viking city of Waterford, the Penneys (Primark) on Barronstrand Street incorporates a section of the 13th-century city walls into the shop. It's not concealed by clothes but, instead, displays informational boards to educate shoppers about the history of the city.

These quasi-museums could potentially herald the future of archaeological finds in urban areas in Ireland. Maybe in another 1,500 years there'll be a glass panel floor above whatever's left of Busáras for future food shoppers to see.

ST PATRICK'S CHAIR
Altadaven, County Tyrone

Deep inside the dark primeval woods of the People's Millennium Forest outside Augher in County Tyrone is a place that legend calls Altadaven, or the more sinister-sounding Anglo version, the Demon's Cliff.

In local lore, it's said that St Patrick went to Altadaven to banish the pre-Christian religion that was practised there. He banished the druids, or demons, over the cliff. He then sat on a chair situated next to the cliff and said mass, which converted many of the locals to Christianity. That's why these days that chair is famously known as St Patrick's Chair. St Patrick: the man, the myth, the legend.

And to prove this, we've got the historic St Patrick who was kidnapped and taken to Ireland in the 5th century from Great Britain, preached Christianity across the island, and wrote two books, *Confessio* and *Epistola*, that detail some of his life.

Then we have the more glamorous legendary St Patrick, who met Oisín when he left Tír na nÓg, banished the snakes

from Ireland, turned the Children of Lir back into humans from swans, and sat down on a chair in the woods in Augher, and made it blessed. Except the chair is actually a three-metre high, two-metre wide, partially carven block of sandstone, sitting on the rocky outcrop.

His influence on the place to this day is still strong, and it is said that if someone were to sit on St Patrick's Chair and make a secret wish, it will come true within the year. That gives this place its other name, the Wishing Chair. Pilgrims and tourists visit here often to test the chair's claim.

Near the chair is a holy well that is named in honour of either St Patrick or St Brigid, depending on your preference. The water of the well is said to never run dry, and is another one of our famous wart cures. Strewn across this opening in the tall fir trees you will see rags stuck to trees, coins and mementos given as votive offerings by pilgrims.

The place used to be famous for its Lughnasa celebrations called 'Big Sunday' or 'Heather Sunday' on the last Sunday of July or August, but this quarter-day festival has unfortunately died off in more recent times.

St Patrick's Chair near Augher is one of the most remarkable looking in the country, but by all means, is not the only St Patrick's Chair in Ireland.

Coney Island in County Sligo has its own St Patrick's Chair, which is also said to be a wishing chair. There's a St Patrick's Chair on the Hill of Lara in County Westmeath, which people used to claim was a cure for backache. There's a St Patrick's Chair on Slemish Mountain in County Antrim.

According to locals, this is where St Patrick lived as a slave when he was young, and people climb the hill every St Patrick's Day to sit on the chair he once sat on.

That said, all these dedicated chairs make sense because, when St Paddy was travelling all across the country banishing those snakes and spreading the faith, he would need to rest his old bones somewhere every now and then.

However, the chairs only the tip of the iceberg. In Lullymore, County Kildare there's St Patrick's Footprint, where he is said to have stood when he established a monastery. There's another St Patrick's Footprint on Red Island which isn't an island anymore, off the coast of Skerries in County Dublin. This is where St Patrick chased some natives who stole and ate his goat, and Paddy's first step onto Red Island to confront them is still there to this day. Even at low tide there is always water in this footprint. There's yet another St Patrick's footprint, this time in Castleconnell, County Limerick. It's on a stone next to a tree near the River Shannon. It's said that upon this stone, St Patrick banished the last snake in Limerick into County Clare, and there's an imprint from his staff as well as his foot.

Moving further up his anatomy, there's St Patrick's knee print on a stone outside Drogheda, County Louth, where he prayed one time. There's a kneeling stone of St Patrick in Ardagh, County Longford, where he possibly knelt before an Irish king.

This is not an exhaustive list, and it's truly amazing that there's a flat surface left in the country with the number of

dents he was making on the land from standing, kneeling or sitting everywhere he went.

What does this say? Is it that the 5th-century Romano-British man had hundreds, or thousands, of little random encounters across all of Ireland that local stories are retold to this day? Or that his legend grew and grew over the centuries so that any little irregularity in the land was explained by an invented interaction by St Patrick? Take your pick.

WEIRD LISTS

WEIRD PLACENAMES

Let's get something straight. No placename is weird to the people who are from that area. However, plenty of placenames in Ireland are mispronounced – at least in relation to how locals say them. Some placenames are so unique that, aside from the run-of-the-mill tourist errors, folk only two fields away get it wrong too. Here's a few:

Lemanaghan – A village in County Offaly that has some important shrines to St Manchán. This is pronounced 'leh' (like 'le' in French) and 'monaghan' (like the county), which is pronounced 'monna-hin.' The correct pronunciation is 'Leh-monna-hin'.

St Faithleach's Well – A saint's well outside Ballyleague, County Roscommon, that's said to have a cure for stomach ulcers and hay fever. Faithleach is a fairly old Irish name and is pronounced 'fall-yuh'.

Elphin – This town in County Roscommon is famous for its 18th-century windmill and as being the disputed

birthplace of novelist and poet Oliver Goldsmith, who wrote *The Vicar of Wakefield*. It is pronounced with two distinct syllables – 'el-fin', like 'the end' in Spanish.

Rathcroghan – A complex of ancient royal sites in County Roscommon, including Oweynagat. Like with many Irish placenames, the 'gh' in the middle of the word is pronounced as a soft 'h' sound, and the 'g' is silent. Rathcroghan is 'rath-craw-han'.

Cahir – A town in County Tipperary and home to Cahir Castle, it was one of the filming locations for the 1990s children's television show *Mystic Knights of Tír na nÓg* (basically an Irish version of *Power Rangers*). It's pronounced like the one-syllable 'care'.

Dunany – A townland in County Louth where you can find a big stone known as The Madwoman's Chair, which is said to cure madness if you are mad and you sit on it, or curse you with madness if you're sane and you sit on it. It comes from the Irish for 'Áine's fort' and it's pronounced 'duh-neigh-nee.'

Legan – A village in County Longford that has a 17th-century tomb with a statue of a soldier on it called the Stoneman of Legan. There are two correct local pronunciations, either 'Lee-gan' or 'Lay-gan.'

Kesh/Keash/Keshcorran Caves – These are caves in County Sligo that are said to be a gateway to the underworld. There are traces of human habitation in the caves going back to the Stone Age. Locals pronounce them 'Kay-sh'.

Killaloe – A town in County Clare that, for a few years in the 11th century, was effectively the capital of Ireland because the High King of Ireland at the time, Brian Boru, had his base there. 'Kill-ah-low' = bad; 'Kill-ah-loo' = good.

Uisneach – The ceremonial centre of Ireland. This is a broad hill in County Westmeath, which used to be considered the geographic centre of Ireland. It isn't, though it's not that far off, and is still an important place to celebrate Bealtaine/May Day in Ireland. It can be pronounced 'Ush-knock' or 'Ish-knock' – both are fine.

WEIRD EVENTS

Irish Bog Snorkelling Championships
An event in County Monaghan, usually in the autumn, where competitors must cross a course of bog water using flippers and a snorkel in the shortest amount of time.

King and Queen of the Roads Festival
An annual road-bowling event in County Cork. Road bowling is a peculiarly Irish sport that involves throwing a metal ball down a country road in the fewest throws possible.

The Puck Fair
An annual August festival in Killorglin, County Kerry, where a goat is led down from the nearby mountains and crowned the King of the Fair. For most of its history – and it is the oldest festival in Ireland – the King Puck would stand atop a high stage in Killorglin for the whole three days but, since 2023, he goes up and down intermittently.

All-Ireland Sheep-Shearing Championships, ShearFest

An annual battle of the sheep shearers from all over the world who journey to County Galway every June to determine who is the best, neatest and fastest sheep shearer of them all.

Púca Festival

An annual festival in Trim and Athboy, County Meath. Held in October, it celebrates Ireland's ancient connection to Halloween with music, fires and spooky processions.

Festival of the Fires

At the beginning of May on the Hill of Uisneach in County Westmeath, revellers assemble to celebrate the traditional beginning of summer in Ireland by lighting a great bonfire on top of the hill and dancing and parading in druidic-looking getup.

Durrow Scarecrow Festival

A kitsch annual summer festival where the town of Durrow in County Laois is taken over for a week by elaborate scarecrows of all sizes made by the locals, which are displayed in various parts of town.

TedFest

An annual festival in March on Inis Mór, County Galway, where punters go to celebrate the popular 1990s' television

show *Father Ted* by dressing up like nuns and priests, holding quizzes, lovely-girl competitions, quoting the show no end and drinking.

Bloomsday

The events of the novel *Ulysses* by James Joyce all took place on 16 June 1904. The celebration in honour of the book and its protagonist, Leopold Bloom, is held on this day every year. People re-enact the events of the book, many dress up in Edwardian clothing and some Dublin restaurants even serve the meal that Bloom ate on that day. Performances, readings, local festivals and tours mark this special day on the literary calendar.

Slane Viking Festival

This is a big medieval and Viking re-enactment at the historic Slane Castle, County Meath that takes place each May.

Macnas Parade

At Halloween in Galway City, performers parade down the city's streets decked out in spooky and stunning threads.

WEIRD FOODS

Rissole

A fast food you'll only find in Wexford Town, County Wexford. It's a battered or breaded deep-fried potato cake. It began as a waste-saving exercise by local chippers who didn't want to throw out the previous night's chips, so they mashed them up with herbs and onions and re-cooked them.

Boxty

A potato-and-flour pancake that's particularly popular in northwestern counties like Leitrim and Sligo.

Coddle

A centuries-old traditional stew from Dublin. There are a few varieties but, for the most part, it's a stew with cooked sausages and ham.

Mikado

An Irish biscuit that comprises a biscuit base topped with coconut covered marshmallow strips on either side and a line of jam in the middle. Not to be confused with the

French chocolate-covered biscuit sticks or the Gilbert and Sullivan opera.

Banshee Bones

Corn snacks that embrace folklore by being shaped like a banshee's bones and are salt and vinegar flavoured. They were popular in the 1990s and 2000s, then were discontinued for years, before making a semi-permanent return in 2020 – they are now only available around Halloween.

Monster Munch

Top-level spicy flavoured Irish corn snacks shaped like a monster's foot. Meanies get a notable mention too: they're the pickled-onion cousin of a monster's foot, with a different texture.

Spice Burger

A fast-food burger that comprises meat, herbs, spices and onions cooked inside a breadcrumb exterior and served without a bun or salad.

Batter Burger

Pretty much what it sounds like. A normal beef burger, battered and deep-fried, eaten without a bun or salad.

Wurly Burger

While we're on the burger bus, a wurly burger is a batter burger in a bun with salad. A Dublin delicacy.

Wrappos

A wrappo is a newer fast-food delicacy in Dublin. It's a spring roll filled with curry, rice and chicken, served with a small tub of curry sauce for dipping.

WEIRD HAPPENINGS

The Tullamore Hot-Air Balloon Disaster

In 1785, the early days of hot-air balloon travel, one balloon taking off from Tullamore, County Offaly got caught on a chimney. It set that building on fire, and subsequently burned down a good portion of the town. Since then, Tullamore's coat of arms depicts a phoenix being reborn from its ashes, just like the town after one of the first hot-air balloon disasters.

The Vanishing Lake of Loughareema

There is a mysterious lake in County Antrim that regularly fills to its brim and then totally empties, a change that can happen in the span of a day. Its emptying mechanism is not fully understood, which has inevitably spawned a multitude of ghost stories.

The Time *Most Haunted UK* Came to Charleville Castle in County Offaly

In 2002, the first series of the hit UK television programme *Most Haunted* brought its ghost-hunting team along with

their night-vision cameras to Charleville Castle in County Offaly to try to communicate with spirits. At one point in the show, Derek Acorah – the medium of the team – was attacked by a ghost whilst off-camera in the basement of the castle.

The Hijacking of Aer Lingus Flight 164

On 2 May 1981, an Aer Lingus flight from Dublin to London was hijacked by an Australian passenger and flown to an airport in France. There was a standoff between the hijacker and security forces, with the hijacker demanding that the Vatican release the Third Secret of Fátima to the public. The hijacker was arrested when special forces boarded the plane, and was sentenced to five years in prison for air piracy.

Dustin the Turkey at the Eurovision

In 2008, Ireland's beloved puppet personality Dustin the Turkey represented Ireland at the Eurovision Song Contest with the masterpiece that is 'Irelande Douze Points'. Shockingly, Ireland was eliminated in the semi-finals.

The Darndale Two

In 1985, two kids from Darndale, County Dublin, snuck onto a DART into Dublin, a ferry to Holyhead, a train to London Heathrow and an airplane heading to JFK airport, evading ticket inspectors and customs the entire way. Their amazing journey was finally halted when they asked a policeman for directions into New York City. The police

quickly realised something dodgy was up and they were swiftly sent back home.

The Time the Eurovision was in Millstreet

By 1993, Ireland had won the Eurovision Song Contest so many times that no venue wanted to host the competition again because of the costs, so an equestrian centre owner in Millstreet, County Cork (population 1,500), offered to host it. Some 25 countries participated, in the smallest town ever to host a Eurovision ever. However, Ireland won again and hosted the 1994 Eurovision in Dublin.

The Horsenapping of Shergar

In 1983, one of the most prized racehorses in the world, Shergar, was stolen. It was suspected that the perpetrators were a cash-strapped IRA, but they have never been caught. They demanded a ransom from the horse's owner, but no ransom was ever paid. It is thought that the horse was killed soon after his capture, but his body has never been found.

St Brendan Finding America

The 6th-century Irish saint and abbot, also known as Brendan the Navigator, *maybe* became the first European to travel to the Americas, beating Christopher Columbus and Leif Erikson to the punch by hundreds of years.

WEIRD WORLD RECORDS

World's Largest Breakfast
This beast of a breakfast can be found at the Hard Boiled Egg Cafe in Cavan Town, County Cavan. It consists of ten sausages and ten rashers, ten eggs, five hash browns, tomatoes, mushrooms, beans, chips and no fewer than ten slices of toast. If you finish the whole thing on your own within thirty minutes, you get it for free. Only a handful of people have managed it in the past ten years.

World's Largest Tea Towel
In 2016, Poplars Linen Trading Company of Westport, County Mayo, made the world's largest tea towel. It measured just under 158 square metres, about the third of the area of a basketball court.

Most Irish Coffee served in three minutes
Rory McGee in the Old Storehouse in Temple Bar served 49 Irish coffees in three minutes on International Irish Coffee Day in 2020.

Largest ever skinny dip

In 2018, 2,500 women in County Wicklow took part in the biggest skinny dip to raise money for a children's cancer charity, Aoibheann's Pink Tie.

Fastest crossing of the North Channel on a paddleboard

This feat was completed in just under four hours by Oisín McGrath, who crossed the channel from Islandmagee, County Antrim, to Portpatrick in Scotland.

Largest group of people dressed as leprechauns

It'd be such a shame if this accolade *didn't* go to Ireland. On St Patrick's Day in 2012 in Bandon, County Cork, 1,263 folk dressed up as leprechauns.

Largest collection of Deadpool memorabilia

Awarded to Gareth Peter Pahliney in Cloghan, County Offaly, in 2023. He has over 2,000 items of Deadpool (the Marvel comics character) memorabilia.

WEIRD FILMS

Beloved Enemy (1936)

Believe it or not, the film *Michael Collins* (1996) is not the first film about the Irish revolutionary hero. In fact, the first one based on his life came out only 14 years after his death. *Beloved Enemy* is a looser take on the life of Michael Collins – called Dennis Riordan in this film – where he is shot, but lives in the end.

Mein Leben Für Irland (1941)

My Life for Ireland is a German World War Two propaganda film. It wasn't made in Ireland, has no Irish people in it, and is in German. The film follows the oppressive persecution of an Irish family by the British, with the idea of portraying the British as barbaric tyrants for German audiences.

Eat the Peach (1986)

After getting laid off, young lads get the idea into their heads to build their own motorcycle wall of death to pull off daring bike stunts.

Rawhead Rex (1986)

Shot in County Wicklow, this cheesy but gory spooky-season flick follows the events in a village torn apart by a ridiculous-looking monster while the villagers get slaughtered and try to figure out what to do. I actually really like this one. Watch it around Halloween.

Leprechaun 4: In Space (1996)

This just barely (if even) scrapes past the criteria of what makes an Irish film, but I couldn't compile this list without making reference to the *Leprechaun* film franchise, which consists of eight films where the titular leprechaun terrorises a cast of characters in whatever ridiculous situation confronts them. In *Leprechaun 4: In Space*, in the year 2096, the leprechaun persecutes a crew of space marines while trying to wed a princess.

Butcher Boy (1997)

Two boys are best friends until a new family moves to town and throws the status quo into disarray. One of the boys, who has a tragic home life, can't handle the change and takes matters into his own hands. This is probably the most famous film on this list, but it's not the most famous Irish film around. It's definitely a weird and psychedelic one with hallucinations of the Virgin Mary, played by Sinéad O'Connor.

Moving Target (2000)

Believe it or not, *Fatal Deviation* is not the only Irish martial-arts movie in existence and, amazingly, *Fatal Deviation* is the less ridiculous of the two. The plot of *Moving Target* involves a nuclear detonator hidden in a six-pack of Beamish stout in Galway City.

The Luck of the Irish (2001)

A Disney live-action film, but this time it's an American teenager who has to foil the efforts of an evil leprechaun.

Studs (2006)

A cheesy Irish soccer film about a team who can't win but then miraculously does, starring Brendan Gleeson.

Irish Jam (2006)

A ridiculous and crazy movie where an American wins a pub in Ireland in a raffle, travels there to claim his new prize, and saves the town from a wicked landlord. Funnily enough, while it's 2006 in the States, it still looks like the 1930s in Ireland.

WEIRD PHRASES

Well – Hello

Well, sham – Hey buddy/pal

Ye/Youse/Yis – You (plural)

You're a holy show – I disagree with your general appearance/You are embarrassing

Give out – To scold/castigate

Flat out – Very busy

Give it who began it – Undertake a task with your best effort

Yer man/Yer one – Masculine third-person identifier/ feminine third-person identifier

The press – The cupboard

Fierce/Pure – An intensifier adverb, 'very'

What age are you? – How old are you?

Grand – Good/OK/Fine

WEIRD CREATURES

Leprechauns

The iconic, emblematic Irish cryptid depicted in Disney films, cartoons and cereal boxes as a tiny man with a green suit, red hair and a beard. Leprechaun lore is more complicated than that historically but, for the sake of simplicity, let's stick with the little magic men with the pots of gold.

Dobharchú

This is essentially a were-otter (pronounced 'door-coo'). It comes from a particular story from County Leitrim from the 18th century where a woman is killed around Glenade Lough by a Dobharchú that emerges from the lake. A headstone on a grave in a local graveyard still depicts this monster to this day.

Púca

Púca (pronounced 'pooka') is an all-encompassing Irish term for a ghost, spirit or devil. They can look like nearly anything, and, to some, both banshees and leprechauns are types of *púca*, along with a whole host of other spirit-like beings. They can be a mischievous or evil presence.

Selkie

A selkie (pronounced 'sell-key') is like a were-seal. It's a legendary creature found in both Irish and Scottish folklore. They can be either benevolent or malevolent.

Mermaid

In Irish folklore, mermaids are called merrows. Medieval depictions of merrows can be seen at Clonfert Cathedral and Clontuskert Abbery, both in County Galway.

Dolocher

A dolocher (pronounced 'dull-uh-ker') is a monster of 18th-century Dublin folklore. It's a demon pig that spread fear by prowling the dark alleyways and corners of the streets of Dublin and mauling people. It was said to be the spirit of a prisoner returned to life to seek revenge.

The Abominable Snowman

Despite the Abominable Snowman (or yeti) being a Himalayan creature, it was first reported by an Irishman from County Westmeath. Colonel Bury was leading a reconnaissance expedition to Mount Everest in 1921 when he spotted footprints in the snow that could have come from a large wolf or a wild man.

Banshee

A banshee – from the Irish *bean sí*, meaning 'fairy woman' – is a female spirit that's a meant to be an omen of death. If

you hear the banshee's wail outside your house at night, someone you know may be dead the next morning.

Dullahan

A headless horseman who comes to escort people to their death. Both the banshee and the dullahan (*dúlachán*) are depicted masterfully in the 1959 Disney film *Darby O'Gill and the Little People.*

Caoránach

According to legend, Caoránach (pronounced 'kay-raw-nock') is the mother of the devil, who St Patrick banishes to Lough Nacorra on the far side of Croagh Patrick in County Mayo. In other stories, Lough Nacorra is where St Patrick banishes the snakes of Ireland.

Fear Gorta

The Hungry Man – *fear gorta*, pronounced 'far gurtah' – is an emaciated spirit that roams the roads begging. The spirit can be generous, but only if generosity is shown his way first.

WEIRD STATUES

Bill Clinton
A life-sized statue of the 42nd President of the United States of America teeing off has pride of place in Ballybunion, County Kerry.

John Wayne and Maureen O'Hara
Cong, County Galway, was the location for 1952 film *The Quiet Man*, starring Wayne and O'Hara. The two stars now have their own statue in town.

The Monkey
In Clonakilty, County Cork, stands the statue of a monkey named Tojo. Tojo was a real monkey, who came to Clonakilty in 1943 when a United States Air Force plane crashed nearby with the monkey on board. Tojo died not long thereafter, but the story is so fondly remembered that he got his own statue.

The Ferryman's End
Probably the weirdest, most-iconic statue in all of Ireland. Victor's Way is a sculpture park in County Wicklow that

226

features an array of bizarre statues. The flagship statue, *The Ferryman's End*, is a figure of a giant man attempting to crawl out of a stagnant pond.

Darth Vader and Yoda in Ballyferriter

Outside the Ceann Sibéal Hotel in Ballyferriter, County Kerry, is a ramshackle looking pair of rubber statues of characters from *Star Wars*. Why? Well, it's simple enough – that part of County Kerry is where a lot of the recent *Star Wars* films were shot.

The Stations of the Uncanny in Multyfarnham Friary

Outside Multyfarnham Friary in County Westmeath is a Stations of the Cross. Similar can be seen in many churches, except this one has all-white, life-sized statues. They look like something straight out of *The Lion, The Witch and The Wardrobe*, and are totally worth seeing.

Tír Sáile Sculpture Trail

Not one statue, but many! The Tír Sáile Sculpture Trail stretches along the coastline of north County Mayo, and is the largest public art trail in Ireland. If you follow it, you can see statues such as A Home for the Children of Lir, which is designed to look like a stone-and-wood shelter for the mythical children who were cursed to live as swans for hundreds of years.

The Rhino in the River Dodder

In the River Dodder at Milltown in Dublin there's a random statue of a rhinoceros standing in the water. It's been there for more than 20 years, and no one knows who put it there or the significance behind why it's a rhino.

Woolly Mammoth Statue

There's a railway museum in Belturbet, County Cavan. Nothing out of the ordinary there. However, behind the museum is a life-sized statue of a woolly mammoth.

Dog Statue, Athenry Train Station

Outside Athenry Train Station in County Galway, you can find a tall black statue of a hound. It's terrifying looking, and has no information sign to say what it is or what it wants from us. Maybe it's meant to deter non-ticket holders from hopping on the train?

WEIRD MUSEUMS

Glenview Folk Museum
A private collection in County Leitrim that, amongst a trove of historic folk-life artefacts, holds the largest collection of egg cups in the world.

Cavan County Museum
This museum in Ballyjamesduff, County Cavan, is interesting and informative in its own right with its displays of ancient history and folk life of Cavan. However, the main pull is the life-sized replica of World War One trenches situated behind the museum, equipped with machine-gun sound effects.

Clonakilty Black Pudding Museum
Need I say more? I will anyway. Clonakilty is *the* brand of black pudding in Ireland. And to prove this, the County Cork company made a museum and visitor centre with tours of rural Irish life to showcase the evolution of the branded black pudding over the ages.

Castlerea Railway Museum

Castlerea Railway Museum has the largest private collection of railway artefacts in Ireland. Expect to see railroad signs and signals, entire train carriages, and all the bells and whistles.

The Entrance Museum

This museum in Cashel, County Tipperary, contains both ancient artefacts and objects of modern folk life. What sticks out here is their specimen of ancient bog butter that you are allowed to pick up and hold.

Ulster American Folk Park

A unique museum in Omagh, County Tyrone, detailing the very specific story of the connections between Ulster and North America.

Rainbow Ballroom of Romance

This is a dancehall in Glenfarne, County Leitrim. It was hugely popular in the showband days of the 20th century, but still gets plenty of gigs these days. On the upper floor of the Rainbow Ballroom is probably the only showband museum in the world, containing records, photographs and, most importantly: Joe Dolan's tie.

Doagh Famine Village

A fascinating folk-history museum in County Donegal that replicates rural living from the pre-famine times (pre-1845) until today.

Irish Museum of Time

This museum is in Waterford City, County Waterford. It's Ireland's only horological museum and counts in its collection various clocks, timepieces and watches.

Irish Wake Museum

Also located in Waterford City, County Waterford, this museum gives guided tours of the fascinating Irish phenomenon of death, wakes and burial.

Weird Acknowledgements

There's no end to the people I'd like to thank for helping me along the way to writing this book.

Firstly, huge thanks to my family, for supporting me in so many ways throughout the whole process. Thanks to the everyone at the publishers Hachette Ireland, and especially Ciara Considine who saw potential in what I was doing and guided me along the way.

Thanks also to Stephen Riordan and Joanna Smyth.

Big thanks to Eoin Whelehan for his illustrations and for creating a new visual identity for Weird Ireland.

Super thanks to everyone who follows Weird Ireland on whatever social-media platform, for liking the content, commenting, recommending places and topics to make videos out of, none of this would have come without ye.

And thank you reading this book, for picking it up and taking the time to do so. Big time appreciate it.